IMAGES
of America

DETROIT
RAGTIME AND THE JAZZ AGE

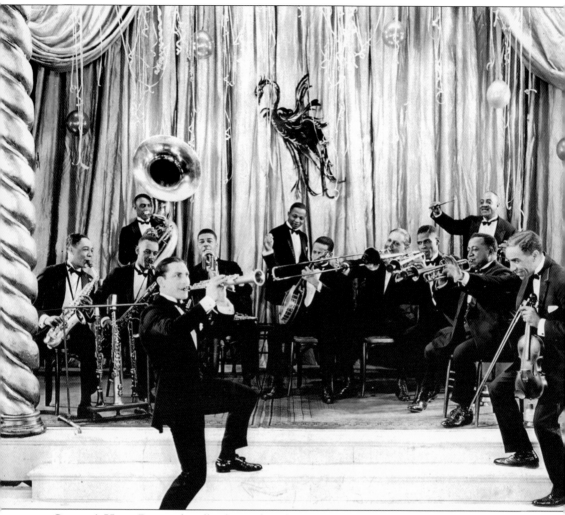

GETTIN' HOT. Detroit bandleader and violinist Leroy Smith (right) stands in front of his orchestra, as an unidentified soprano sax player (left) mounts the steps of the stage in a posed "action" scene at an unidentified location. The photograph dates from the late 1920s. (Courtesy of the E. Azalia Hackley Collection of Negro Music, Dance and Drama, Detroit Public Library.)

On the cover: **FIRST GENERATION BIG BAND JAZZ.** Leroy Smith and his orchestra are seen in an unidentified location in Detroit around 1918. From left to right are (first row) Harry Brooks, piano, and Leroy Smith, violin; (second row) leader Ed Beeler (pictured on back cover), drums; Harold Henson and Stanley Peters, reeds; and Fred Peters, brass bass. (Courtesy of the E. Azalia Hackley Collection of Negro Music, Dance and Drama, Detroit Public Library.)

IMAGES
of America

DETROIT
RAGTIME AND THE JAZZ AGE

Jon Milan

ARCADIA
PUBLISHING

Published by Arcadia Publishing
Charleston SC, Chicago IL, Portsmouth NH, San Francisco CA

Printed in the United States of America

Library of Congress Catalog Card Number: 2008935189

For all general information contact Arcadia Publishing at:
Telephone 843-853-2070
Fax 843-853-0044
E-mail sales@arcadiapublishing.com
For customer service and orders:
Toll-Free 1-888-313-2665

Visit us on the Internet at www.arcadiapublishing.com

CONTENTS

ACKNOWLEDGMENTS

This book could not have been completed without the interest, generosity, and assistance of many individuals. For their encouragement, time, information, artifacts, and photographs, I owe a great debt to Mike Montgomery, Nan Bostick, Charlie Rasch, Rudy Simons, Duncan Schiedt, Josh Duffee, Arthur LaBrew, Robert Essock, Stan and Steve Hester, Matt Lee, Evan Milan, Greg Hathaway, Chris Smith, Romie Minor, and the E. Azalia Hackley collection.

For technical assistance, I would like to thank Durwood Coffey for his tireless hours of scanning and preliminary art direction. For their proofreading, advisement, and encouragement, I would like to thank Christine Schinker, Dorrie Milan, Rudy Simons, Nan Bostick, Arthur LaBrew, Mike Montgomery, Charlie Rasch, James Dapogny, Mike Karoub, Emily, Benjamin and Evan Milan, Brian Delaney, Scott Clauser, James Meeker, Janet Pecot, V. Thomas Adams, Jeff Sizemore, and Greg Hathaway.

Due to space considerations, many of the attributions appearing in captions have been shortened or abbreviated. In order to provide full credit to the sources, I would like to list the sources requiring a more formal attribution in their complete form here. Photographs that are attributed to the Hackley Collection have been provided courtesy of the E. Azalia Hackley Collection of Negro Music, Dance and Drama, Detroit Public Library; items attributed to the Montgomery archive are courtesy of Michael (Mike) Montgomery; and items attributed to the Hester collection are courtesy of Stan and Stephen Hester. All other parties are named appropriately, and my great thanks and appreciation to all of these individuals. All images without attribution are from the author's collection.

I dedicate this book to my brother Phillip B. Milan (1950–1987), who bought me my first Scott Joplin record when I was 11 years old; to my mother Ann A. Milan (1926–1999) and my father Gayle L. Milan (1924–2004), who suffered through years of my early, at times seemingly incoherent, piano banging and spent countless hours with their eccentric son while he poured through piles of old sheet music and records; and to Charlie Rasch, my mentor, who showed me how the piano should be played and introduced me to Mike Montgomery, Stan and Steve Hester, Bob Seeley, Dave Wilborn, Kate and Warren Ross, Howard Rasch, and Martha Sewell—some of greatest people I have ever come to know.

INTRODUCTION

When we think of ragtime music, our minds might automatically turn to Sedalia, Missouri, and Kansas City. When jazz is the topic, we naturally think of New Orleans—these places are generally understood to be where these musical forms originated. In both cases, however, the story continues. Musical idioms are dynamic by nature, and ragtime and jazz were enhanced, changed, and developed by composers and performers across the country. Every major metropolitan area, and each small town in between, had a stake in the development of what we know as ragtime and jazz music, and the focus here is Detroit—a city that played an important and historically significant role in the development of both idioms.

Putting together an image-driven journal of Detroit in the ragtime and jazz age poses significant challenges as Detroit can be a mysterious place. Over the last 100 years, Detroit's landscape has changed through urban renewal, highway development, social unrest, and demographic migration. In terms of square miles, it is a vast city with a relatively small downtown business section. Within its boundaries are disconnected districts and pockets, possessing old and deep ethnic, cultural, and historic roots. Its labyrinth-type network of downtown streets—laid out in a period predating the automobile—fan out from a central point, transcending narrow cross streets that frequently culminate in abrupt dead-ends. In terms of historic preservation, it has a poor track record, and structures that one might hope to find still standing are often long gone. Others may be altered beyond recognition or abandoned and in ruins.

Finding traces of individuals who played a role in Detroit's music scene of 100 years ago and attempting to reconstruct their life stories can sometimes seem impossible. For many, it is like trying to sew together a complete cloth from fragments, most of which cannot be found. Many of these people are forever lost to time. This is especially true of the artists and composers who played a part in Detroit's ragtime scene. Many of these people seem to have emerged from the shadows, played small roles in a narrow spotlight and then "jumped off" into the unknown. Of these, almost no information is known, and no photographs have been found. The problem of tracing these individuals is further compounded by some of the obvious issues related to poverty, racism, and sexism.

At the dawn of the 20th century, many commercially successful compositions coming out of Detroit's Whitney-Warner (and later) Jerome Remick Publishing Company were written by women who worked in the office performing various tasks including selling sheet music, filling orders, demonstrating the latest publications on the piano, or whatever else was needed at the moment. Although many were talented and prolific composers, the publisher often obscured their gender by omitting their first name on the composer credits, opting instead to use a first initial.

While this practice later changed, Detroit's female composers of the ragtime era were seldom given anything approaching the publicity and credit they deserved. In fact, only a few are known to be featured on the covers of Remick's supplemental anthologies. For the rest, we are left to guess the identities of the women who anonymously populate the few surviving photographs taken in the Remick offices. In addition, researching their lives is further complicated by the practice of changing names through marriage.

Fortunately, some biographical information on Detroit's ragtime women has become available through the painstaking research of Dr. Nora Hulse and Nan Bostick in "Ragtime's Women Composers: An Annotated Lexicon," published in the *Ragtime Ephemeralist* in 2002.

African American composers often faced similar treatment, rarely receiving credit and publicity commensurate to their talent. They too rarely found photographic representation on Remick publications, and their photographs and biographical particulars remain difficult to find. For help in this area, we are indebted to the work of Arthur LaBrew for many publications, including his two-volume work, *The Detroit History that Nobody Knew, 1800–1900*, and his collaborative work with Nan Bostick, "Harry P. Guy and the 'Ragtime Era' in Detroit, Michigan," published in the *Ragtime Ephemeralist* in 1999.

Despite the efforts of these, and other, individuals, there are many mysteries, unknowns, and unanswered questions. The details of some of these lives may be lost forever. One example is Bart Howard, known by reputation to have been the king of ragtime pianists in Detroit during the second and third decades of the 20th century, yet despite the accumulation of my own research and more than 45 years of research by Mike Montgomery, Arthur LaBrew, and the late Tom Shea, little has been found, save one published composition, a death certificate, an unmarked grave in Detroit Memorial Park, and an article from the late 1950s in which pianist Paul Howard refers to him as his late cousin. Nothing else is known or has been found.

All of this makes a book of this kind difficult to compile. It is also why it can never be comprehensive. Ultimately, we are left with a fascinating but incomplete sketch; hopefully, one sufficient enough to tell the story.

In its broadest scope, this book should provide a basic understanding of the role Detroit played in the development of the music. It presents people of great fame and renown who spent all or some of their lives in the region, building on their individual contributions, and it introduces and brings to light many obscure and lesser-known individuals whose contributions may be unknown to most, finally being given their due credit.

Beyond the music, the images in this book provide a graphic narrative of Detroit's (and Michigan's) role in the rapid development of the American music publishing, manufacturing, recording, and broadcasting industries. Through the featured advertisements and promotional materials, we can also see how marketing trends and strategies developed and became better targeted as specific consumer segments were identified and better understood by the advertising industry.

In an age where most people seek out information in concise and encapsulated information "bites," the image and caption-driven format of Arcadia publications fill a niche that has been wanting for some time.

When applied to historical subject matter, it poses some obvious advantages. For the casual reader, the photographs and brief captions work together to build a basic understanding of specific eras and places in time. For others, the format may be of a greater value, perhaps helping to fill gaps in research projects by providing rarely seen images and little-known historical details. More importantly, the format may peak the interests of young readers and students and inspire them to dig deeper and discover within themselves an unexplored love for historical research.

It is my hope that *Detroit: Ragtime and the Jazz Age* can provide satisfaction at all of these levels. If it helps in some way to bring about further research and provide more information on the subject, it will prove to be an even greater success.

One

ECHOES FROM THE
SNOWBALL CLUB

During the short span of time between the Civil War and 1900, the country entered into an accelerated age of innovation and technology that introduced practical electric lighting, the telephone, recorded sound, automated music machines, and the automobile. Late in those years, almost without notice, the music that drifted out from the smoky doorways of dance halls, saloons, and brothels began to take on new characteristics. It had a lilting swagger and sway and was played in what they called "ragged" time. Before long, hints of it were evident in the songs and tunes played by the song "pluggers," street musicians, and local dance bands. It was there before it had a name, and suddenly, it was everywhere.

Ragtime is a genuine American creation, an American musical synthesis. Rhythmically and melodically, it owes much to traditional African American dances and songs; its influences can also be heard in the folk melodies of the Eastern European Jew; structurally and harmonically it is heavily seated in Western European tradition. In America at the end of the 19th century, wherever a mixture of these influential populations thrived, ragtime music was in a strong state of development.

One bustling center of this type was in and around Kansas City, Missouri (most notably Sedalia), generally considered the center of the ragtime universe. Other population centers were also active in the development of ragtime music at the time. The fact that Detroit would come to play a significant role in the development of this distinctly American music can be attributed to key factors in its geographic, political, and demographic history.

In the 19th century, European immigrants flocked to Detroit, an up-and-coming city surrounded by commerce-friendly waterways and rich farmland. For African American fugitive slaves, it represented even more—freedom from bondage.

Michigan was a hotbed of abolitionism and a major artery of the Underground Railroad. During reconstruction, many more African Americans migrated north, seeking opportunity in a friendlier, economically sound environment, and rounded out the ingredients that would make Detroit ripe for ragtime development.

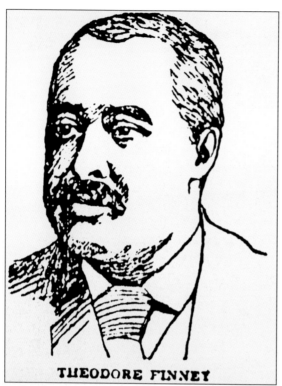

THEODORE FINNEY

THEODORE J. FINNEY (1837–1899).
Born in Columbus, Ohio, African
American musician and bandleader
Theodore J. Finney migrated to Detroit
in 1857. He was an accomplished
violinist, possessing strong leadership
skills and a keen business acumen.
Accompanying him was fellow violinist
and business partner John Bailey.
Together they established the Bailey
and Finney Orchestra, which quickly
became one of the most popular and
sought-after musical contingencies
in the city. (Courtesy of the Arthur
LaBrew collection.)

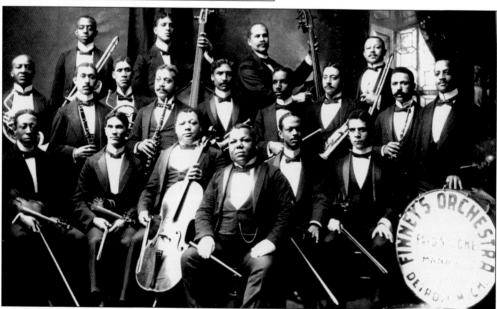

FINNEY'S ORCHESTRA. After the death of John Bailey in 1871, Finney reorganized the music operation. Reintroduced as the Finney Orchestra, the organization experienced significant growth and gained a reputation of excellence throughout the region. With his acute eye for musical talent, Finney continued to enlist the finest musicians available, introducing the city to Harry P. Guy, Benjamin Shook, and the Stone brothers—Fred, William, and Charles. (Courtesy of the Nan Bostick collection.)

MICHIGAN FOURTH INFANTRY BAND, 1861–1865. When military bands were mustered out after the Civil War, a surplus of band instruments flooded the marketplace. Following emancipation, many ex-slaves suddenly found an opportunity to pursue an interest in playing music. Many taught themselves or got by on few lessons, ultimately fumbling through familiar marches and folk songs. This amateur fumbling is believed, by many, to be the origin of jazz improvisation.

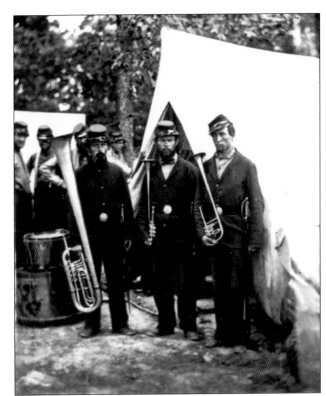

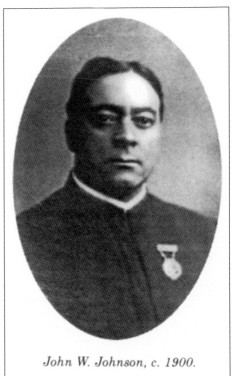

John W. Johnson, c. 1900.

JOHN W. "JACK" JOHNSON (1865–1935). Cornetist Jack Johnson migrated to Detroit from Canada in 1883 to join the Detroit City Band. He performed with a number of touring shows before settling permanently in Detroit, founding the Johnson Cornet Band in 1890. A natural leader and teacher, he soon established a positive working and mentoring relationship with the talented young musicians he brought into the unit. (Courtesy of the Nan Bostick collection.)

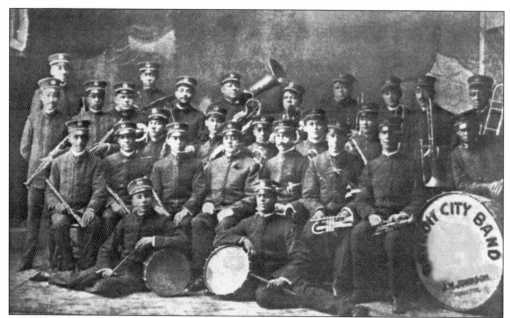

DETROIT CITY BAND. In an undated 19th century photograph, members of the Detroit City Band pose with their instruments around John W. "Jack" Johnson (second row, fourth from left). The band featured the three Stone brothers, including composer Fred S. Stone on euphonium, trombone, alto sax, and piano; William on tuba, double bass, trombone, and piano; and Charles on trombone. (Courtesy of the Hackley Collection.)

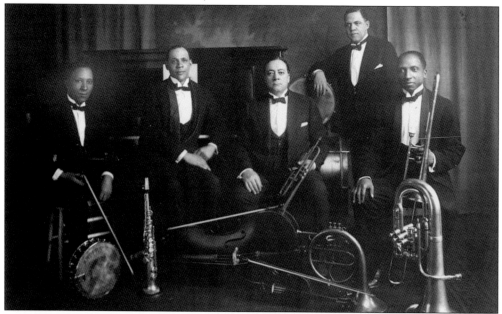

JACK JOHNSON BAND. Jack Johnson (seated, center) led a number of Detroit-based musical ensembles throughout his career, including the Johnson Cornet Band and the Young Men's Orchestra, founded in 1892. He also enjoyed a positive professional relationship with Theodore Finney, often playing with his ensembles and sharing musicians when necessary. (Courtesy of the Hackley Collection.)

"**THE DANCE OF THE BROWNIES.**" In 1893, Effie F. Kamman (1868–1933) was a Detroit actor and piano teacher when she composed "The Dance of the Brownies," inspired by characters in a series of children's books. According to historian Nan Bostick, the piece was purchased by Alton (Allie) Warner for $10, and his friend Bertram (B. C.) Whitney arranged to have it published through his father's firm, C. J. Whitney and Company.

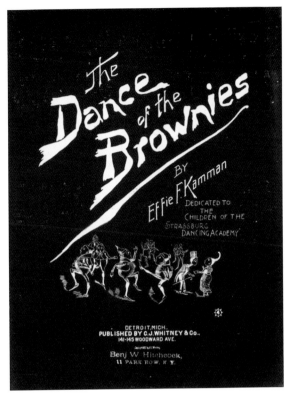

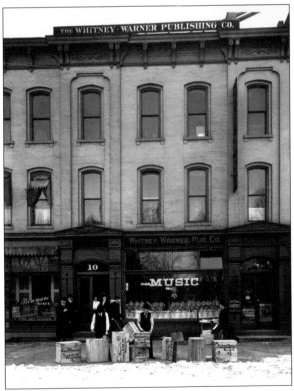

THE BROWNIES AND WHITNEY-WARNER. "The Dance of the Brownies," was so successful, Warner and Whitney decided to start their own publishing company, calling it Whitney-Warner. While they were not great businessmen, they certainly picked a winner and eventually the piece sold more than 500,000 copies. Before her death in 1933, the company—then under Jerome Remick—saw to it that Kamman was compensated more appropriately. (Courtesy of the Library of Congress.)

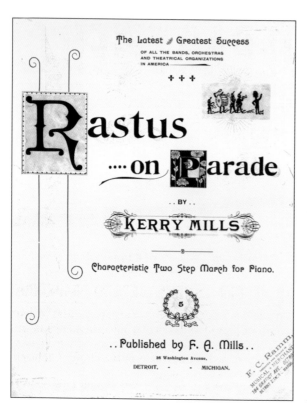

"RASTUS ON PARADE," 1895. It seems the new sound of ragtime emerging from the midway of Chicago's 1893 World's Columbian Exposition had an influence on Detroit composers. One indication is the syncopated, "Rastus on Parade" by Frederick Allen "Kerry" Mills, head of the violin department at the University of Michigan. Its success convinced him to move to New York, where he would write some of the greatest standards of the period.

"BLACK AMERICA." Another early example of ragtime in Detroit is Harry Zickel's 1895 composition "Black America," subtitled, "A Negro Oddity." Published as a march and two-step, it possesses the rhythmic earmarkings and style of a cakewalk, complete with lyrics that would be deemed racially inappropriate in the present day. Soon after its publication, Harry Zickel and his brothers (Detroit music store proprietors) began their own music publishing enterprise. (Courtesy of the Montgomery archive.)

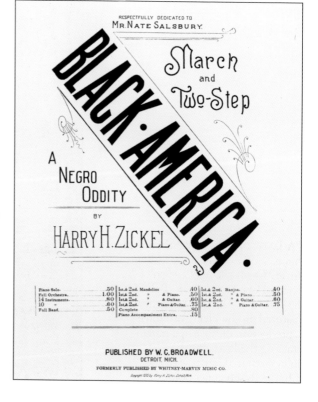

MUSICAL DEPARTMENT.

FINNEY'S FAMOUS ORCHESTRA

Telephone Michigan Main 2877

FRED S. STONE
Director and
Manager

Office Hours, 12 a.m. to 2 p.m., 6 to 8 p.m.

235 ALFRED STREET, DETROIT, MICHIGAN

FRED S. STONE (1873–1912). Born in Canada, Fred S. Stone and his brothers Charles and William migrated to Detroit at a young age. While all three proved to be talented multi-instrumentalists, Fred displayed a unique talent for composing. At 18, he began a writing career, producing many classics of the ragtime era. A natural leader, he assumed management of the Finney Orchestra following Theodore J. Finney's death in 1899.

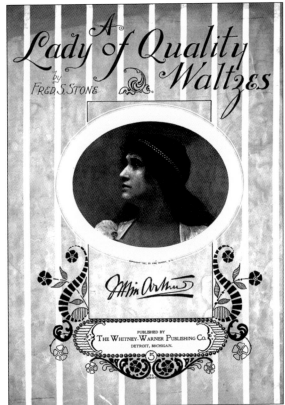

"A LADY OF QUALITY." Stone's first major success as a composer came in 1897 with the publication of "A Lady of Quality" waltzes. Published by Whitney-Warner, the piece was featured on the New York stage in a production of the same name, starring the legendary performer Julia Arthur. (Courtesy of the Charlie Rasch collection.)

15

JEROME H. REMICK

JEROME REMICK (1867–1931). Jerome Remick became interested in the music publishing business through his friendship with Bertram (B. C.) Whitney and Alton (Allie) Warner. Originally groomed for the banking industry, he offered Warner $5,000 for his share of the partnership. Expecting to walk into a glamorous world, he soon discovered the unglamorous truth—the firm was near bankruptcy! Remick quickly realized his first task was to save the fledgling company. (Courtesy of the Nan Bostick collection.)

"MA RAG TIME BABY," 1898. Remick found the solution to Whitney-Warner's financial troubles in his own backyard. Fred S. Stone's latest composition, an instrumental titled "Ma Rag Time Baby," impressed him as possessing strong commercial possibilities. With its publication, his instincts were proven correct—the piece sold beyond his wildest imagination, and its success greatly helped restore the finances of the company. (Courtesy of the Montgomery archive.)

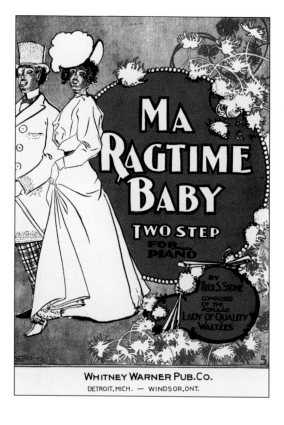

16

SINGING THE PRAISES OF "MA RAG TIME BABY." Remick capitalized on the popularity of "Ma Rag Time Baby" by issuing a song version (lyrics by Charles Stone). In 1900, the tune was performed by John Philip Sousa's band at the world's fair in Paris (Exposition Universelle), where it was awarded a prize for the Most Unique Composition. Historian Nan Bostick speculates it may have been the first ragtime music heard in Europe. (Courtesy of the Montgomery archive.)

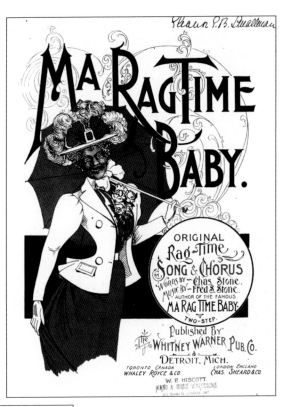

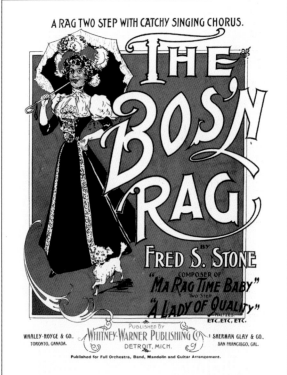

"THE BOS'N RAG." Stone quickly followed "Ma Rag Time Baby" with his 1899 composition, "The Bos'n Rag." In so doing, Stone had inadvertently laid claim to another Detroit music history first, as it was among the earliest publications to be referred to as a "rag." His earlier success, "Ma Rag Time Baby" was one of the earliest known pieces to use the term *rag time* in its title. (Courtesy of the Montgomery archive.)

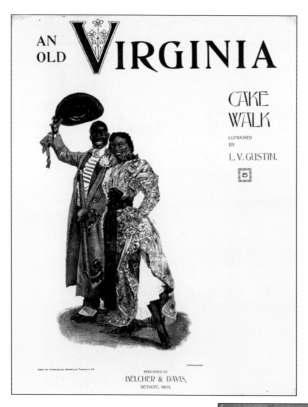

LOUISE V. GUSTIN (1870–1910). Little is known of Louise V. Gustin. Her earliest-known work is "An Old Virginia Cake Walk," published in 1899. She appears in the 1895 city directory as a music teacher residing with Mr. and Mrs. Frank B. Moore. In 1897, she is listed as living with Louisa Moore (widow of Frank Moore). She last appears in the directories in 1899. There are no known photographs. (Courtesy of the Montgomery archive.)

"**LET'S TROT.**" The last-known work by Gustin is "Let's Trot," from 1915. The publication date complicates the mystery surrounding her life. Unverified records indicate she died in 1910. She produced a steady stream of work between 1895 and 1905. However, from 1905 until the publication of "Let's Trot," no evidence of her existence survives. It is possible that the piece was published posthumously.

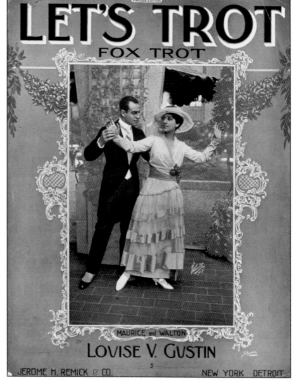

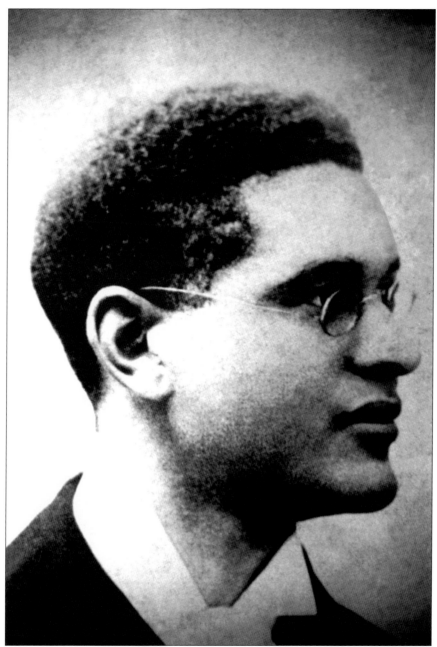

HARRY P. GUY (1870–1950). One of Detroit's greatest contributors to ragtime music was Harry P. Guy. Born in Zanesville, Ohio, Guy migrated to Detroit in 1895 and became an arranger for Whitney-Warner. Guy was a prolific composer and many of his ragtime compositions and songs are considered among the most important examples of the genre. His 1898 composition, "Echoes from the Snowball Club," originally published by the Willard Bryant Company of Detroit, is a ragtime classic that remains in print to this day. Falling on hard times late in life, Guy died penniless and is buried in Detroit's Elmwood Cemetery. In 2003, a group of historians, jazz and ragtime enthusiasts, and concerned citizens held a public ceremony commemorating Guy's life and placing an appropriate marker on his grave. (Courtesy of the Hackley Collection.)

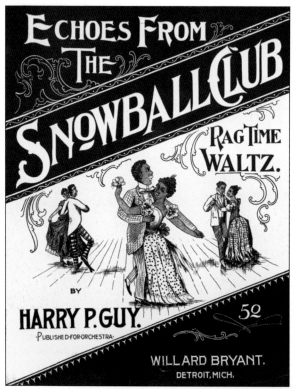

"ECHOES FROM THE SNOWBALL CLUB." Harry P. Guy's 1898 composition "Echoes from the Snowball Club" quickly became a hit and a perennial ragtime classic. Some historians believe its title refers to the days when Detroit's best jobs went to the black bands. It is thought that disgruntled white musicians referred to this "dynasty" as the Snowball Club. Perhaps Guy was using his title as a jab at the "sore losers." (Courtesy of the Montgomery archive.)

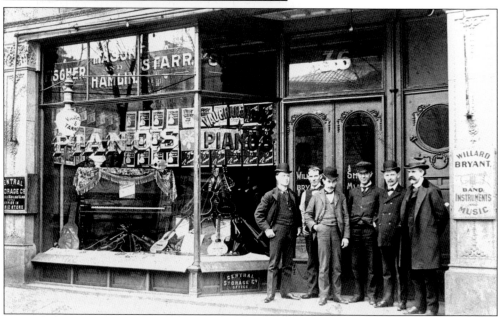

WILLARD BRYANT MUSIC STORE, C. 1900. Harry P. Guy stands third from right, hands in his pockets, flanked by business associates and friends on what appears to be a brisk day in Detroit. Behind them is the Willard Bryant Music Store and Publishing Company. Careful scrutiny reveals the piece of sheet music propped on the piano in the window is Harry P. Guy's "Echoes from the Snowball Club." (Courtesy of the Hackley Collection.)

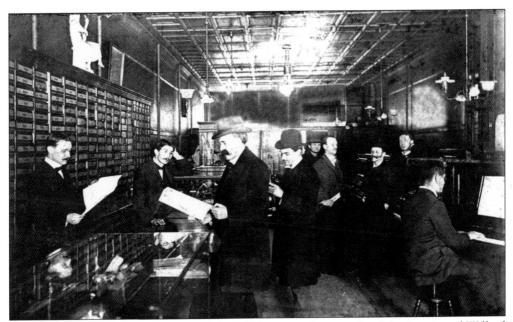

WILLARD BRYANT. Seen here is a rare *c.* 1900 action photograph of the interior of Willard Bryant's Detroit music store and publishing house. Seated at the piano on the far right is Harry P. Guy. Most of the individuals are unidentified, but it is assumed that one of the gentlemen behind the counter is Bryant. (Courtesy of the Hackley Collection.)

AARON "HARRY" GUMBINSKY. Born in Detroit in 1872, Aaron "Harry" Gumbinsky ran away from home at an early age to join the circus. Changing his name several times, he finally adopted his mother's maiden name "Tilzer" and added the German "Von" for "color." By the time he arrived in New York, he was Harry Von Tilzer, destined to write a string of hits that would make him famous. (Courtesy of the Charlie Rasch collection.)

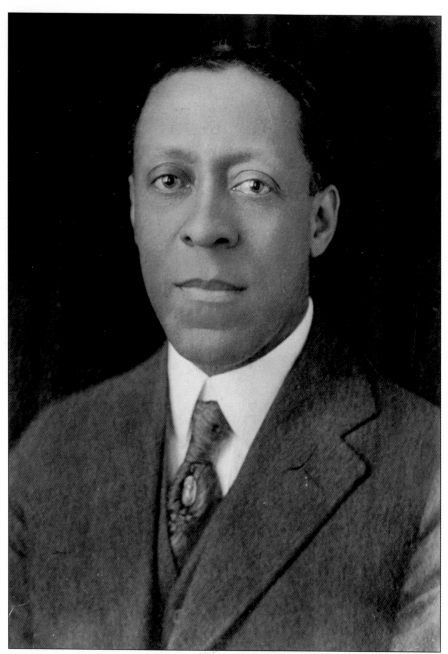

BENJAMIN SHOOK. With the unexpected death of Theodore J. Finney in 1899, Fred S. Stone was able to make the necessary adjustments for assuming management of the Finney Orchestra, but he was also left with the task of filling an empty chair vacated by a talented and respected musician. In response, he sent for Benjamin Shook, a popular, talented violinist and vocalist residing in Cleveland. In very little time, Shook lived up to the challenge, and even contributed some of his own compositions to the band's catalog. He also demonstrated a talent for management and business, which made for a long and successful music career in Detroit as a bandleader and booking agent. In 1950, a 76-year-old Shook was interviewed by Rudi Blesh for his landmark book, *They All Played Ragtime*. (Courtesy of the Montgomery archive.)

"IRENE." Among Shook's more famous composition's written during the ragtime era are "Dat Gal of Mine," published in 1902, and "Irene," a popular waltz song for which he composed the music and the lyrics. Published in 1906 by Grinnell Brothers, it appears in more than one cover edition. (Courtesy of the Montgomery archive.)

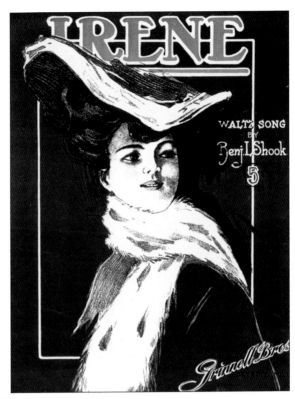

CLOUGH AND WARREN PIANOS. A heavily ornate, 19th-century upright piano graces this photograph advertising card from the Clough and Warren Company of Detroit. With the model number inked in by the salesperson, and displaying no more promotional copy than the dealer's name and address, this pre-1900 showroom sales aid would soon be superseded by slick, feature-laden and consumer-targeted brochures and print advertisements.

TRADE CARDS AND THE MICHIGAN MUSIC INDUSTRY. One of the most prevalent forms of 19th-century advertising was the Victorian trade card. Used by merchants and manufacturers, the cards were mailed, handed out, placed on counters, and provided at purchase points. The above examples advertise piano and organ manufacturers and retailers in Detroit and other cities in Michigan.

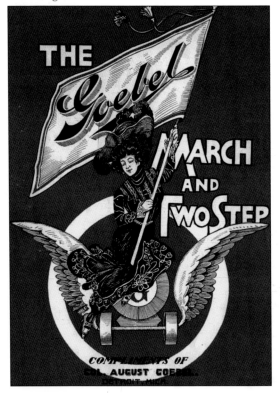

"GOEBEL," MARCH AND TWO-STEP. Prior to the age of the radio advertising jingle, it was not unusual for companies to promote their products through published compositions. This piece, used as a marketing giveaway for Detroit-based Goebel beer, bears the cover footnote, "Compliments of Col. August Goebel, Detroit, Mich." Published in 1900 by Detroit's Zickel Brothers, it features photographs of the Goebel Brewing Company on the back cover. (Courtesy of the Montgomery archive.)

Two

WHERE THAT RAG TIME RIVER FLOWS

As far as is known, the first published composition using the term "rag" was William H. Krell's 1897 "Mississippi Rag." Many followed. The first Scott Joplin rag to appear in print, "Original Rags," was published in 1898 by Carl Hoffman of Kansas City. It is assumed the transaction was supervised by Charles N. Daniels, an operative of Hoffman and a budding young composer and publishing entrepreneur. For reasons unknown, he is credited as the "arranger" on the sheet music. It would be the only time that Joplin and Daniels shared billing on a piece of music, but in time, both would play a major role in the history of ragtime music.

In 1899, Joplin elevated ragtime music to a national craze with the publication of the "Maple Leaf Rag." It was the composition that made him famous—eventually gaining him the title "King of Ragtime Composers." It time, it would sell over one million copies. Riding a wave of new-found fame, Joplin followed his publisher, John Stark, to St. Louis and, eventually, to New York City.

With the overwhelming success of the "Maple Leaf Rag," composers, publishers, and piano manufacturers across the country suddenly realized the immense commercial potential of this new kind of music. In Kansas City, Daniels seized an opportunity of his own, accepting a lucrative offer to come to Detroit and take the helm of one of the largest publishers in the Midwest. At his disposal was a large catalog of proven material, a talent for writing, a keen understanding of the music business, and a professional relationship with some of the greatest ragtime talent in middle-America. Already in the grips of "ragtime fever," Detroit provided Daniels with a strong marketplace and a wealth of untapped ragtime writing talent.

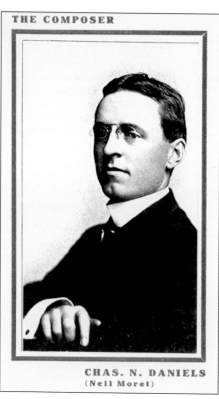

CHAS. N. DANIELS
(Neil Moret)

CHARLES N. DANIELS, (1878–1943). Born in Leavenworth, Kansas, Charles N. Daniel's many talents enabled him to become a major component in the history and development of American popular music. He was a pianist, composer, publisher, businessman, and music marketing pioneer. While his credits appear on many important compositions, most of what is known of him today is owed to historian Nan Bostick, his chief biographer and grandniece. (Courtesy of the Nan Bostick collection.)

REMICK, DANIELS, AND "HIAWATHA." In 1902, Daniels was a proven writer with several hits to his credit, and his latest, "Hiawatha," was rocketing to fame. When Daniels offered his entire catalog to the highest bidder, he learned everyone wanted a piece of "Hiawatha." In the bidding wars, Detroit's Jerome Remick won out, offering Daniels $10,000 for the catalog, and a position with the company. Daniels accepted, and relocated to Detroit.

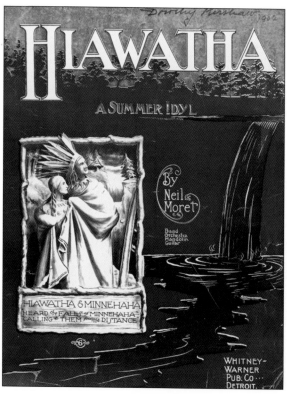

THE $10,000 INTERMEZZO.
Once "Hiawatha" was safely in
his hands, Remick wasted no time
telling the world. "Hiawatha, the
beautiful intermezzo, is the piece
that we recently purchased and
paid $10,000 . . . for the copyright,"
boasts the 1903 advertisement,
adding the fact that it is, "the
highest price ever paid for a musical
composition." At the time of this
advertisement, the company is still
identified as Whitney-Warner.

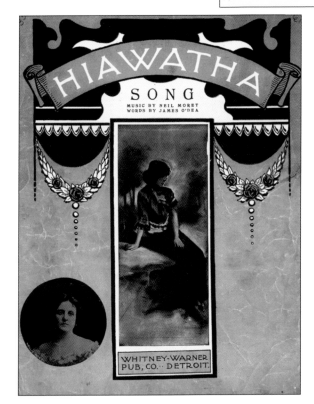

THE HIAWATHA SONG. Replicating
the strategy learned from the success
of "Ma Rag Time Baby," Jerome
Remick reenergized the sales of
"Hiawatha" by issuing it as a song.
Daniels had Harry P. Guy rearrange
it as a vocal selection, with words
contributed by lyricist James O'Dea.
The song version brought on a new
wave of popularity, inspiring many
people to write their own comic
version of the lyrics.

WHITNEY-WARNER CATALOG, 1903. One of the last catalogs issued under the Whitney-Warner name, this 1903 catalog features many of the selections that Jerome Remick purchased in the arrangement that brought Charles N. Daniels to Detroit. It also includes material that came to Remick through the purchase of the Carl Hoffman catalog, arranged by Daniels in 1903.

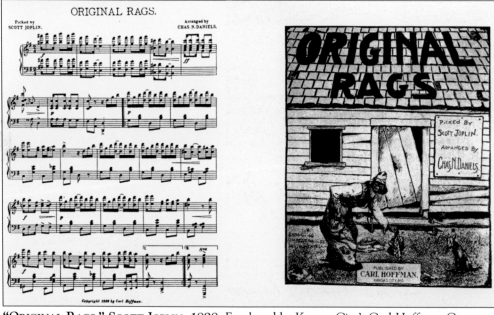

"ORIGINAL RAGS," SCOTT JOPLIN, 1898. Employed by Kansas City's Carl Hoffman Company for a number of years, Daniels was aware of the commercial value of its catalog. Purchasing it on behalf of Remick in 1903, he succeeded in bringing an important piece of the Missouri ragtime universe to Detroit and provided Remick with a wealth of commercially viable material, including Scott Joplin's "Original Rags," offered here in Remick's catalog.

ATTACK OF THE INDIAN INTERMEZZOS. Historian Nan Bostick often muses that her great-uncle Charles N. Daniels created a national "Indian intermezzo nuisance" when he wrote "Hiawatha." It certainly started a craze. His affiliation with the Missouri ragtimers brought him additional "Indian" success with Charles L. Johnson's "Iola" in 1906—surviving to this day on the lips of children everywhere as "Slide Down My Rain Barrel" and "Oh, Say, Oh Playmate."

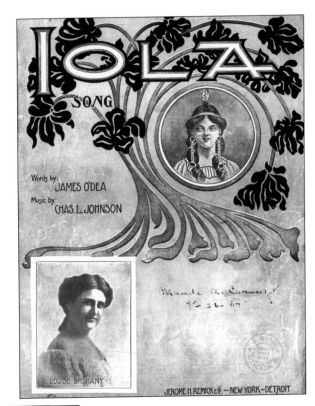

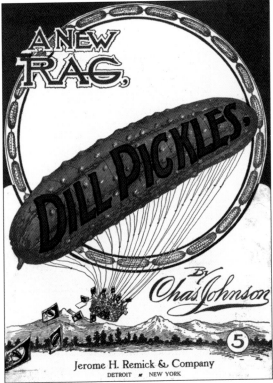

"DILL PICKLES." Charles N. Daniels's affiliation with Charles L. Johnson "paid off" in the form of big profits for Remick. In addition to "Iola," Johnson provided the company with a piano rag that outsold everything. It was called "Dill Pickles" and it, very quickly, sold more than one million copies when it hit the music stands in 1906. (Courtesy of the Evan Milan collection.)

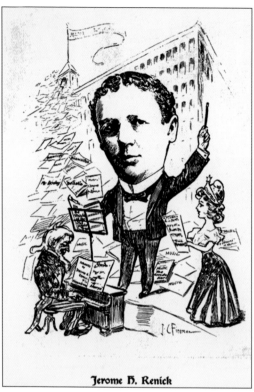

Jerome H. Renick

"THE COLOSSUS OF DETROIT." By 1904, Jerome Remick had built the Whitney-Warner company into the largest music publisher in the world and the most extensive retailer of music in America. He was also a major proponent of the Detroit Symphony Orchestra and instrumental in bringing the orchestra's founder, Ossip Gabrilowitsch, to the city for that purpose. Here Remick is lampooned in cartoon form, leading his musical empire. (Courtesy of the Nan Bostick collection.)

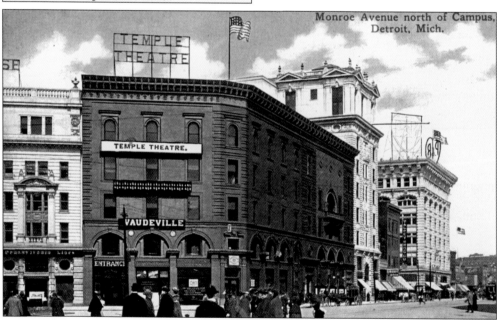

Monroe Avenue north of Campus, Detroit, Mich.

VAUDEVILLE. Local song pluggers and wannabe songwriters flocked around the stage door of major vaudeville houses on the scant hope that they could convince a major star to feature their material. Every major circuit ran through Detroit, and one of the city's most popular vaudeville houses was the Temple Theatre. Built in 1901, it was primarily under contract to the Keith Circuit, which featured some of America's biggest stars.

"Elseeta," 1900. Composers and publishers knew the fastest way to a hit was convincing a top performer to use their material on the road. Fred S. Stone's "Elseeta," was composed for the exotic dancer Elseeta. Billed as "the Dancing Marvel," she was a rising star on the circuit at the dawn of the 20th century. Her image also graces the cover of "Hearts are Trump" by L. W. Young. (Courtesy of the Montgomery archive.)

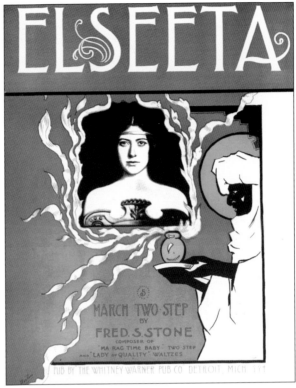

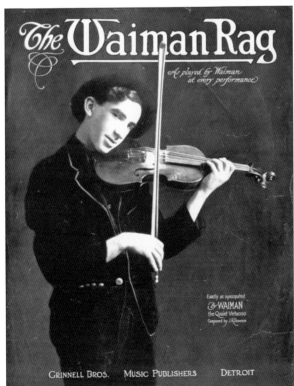

"Waiman Rag." Named for popular vaudeville violinist Waiman, the "Waiman Rag," was penned by Michigan's J. R. Shannon in 1910 and published by Grinnell Brothers. While there are no available sales records on the number, it did considerably well for an instrumental, selling beyond its initial print run. Waiman appears on the cover of several compositions from the early years of the 20th century, including W. C. Handy's "Memphis Blues."

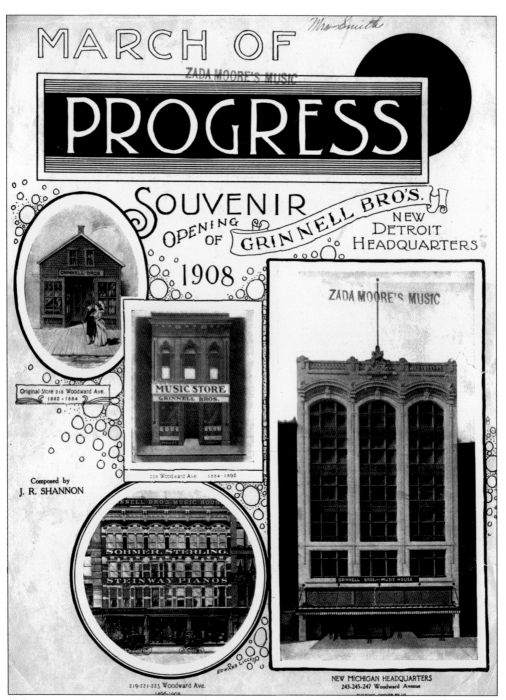

"March of Progress," 1908. With a photographic chronology of the Grinnell Brother's Detroit locations, dating back to 1882, the company's "new" headquarters is heralded musically in the "March of Progress," by J. R. Shannon. Essentially another giveaway item used to generate interest and business, the march is backed by a full-page advertisement for the Grinnell Brothers Piano, complete with endorsements by violinist Maude Powell and baritone Francis Rogers. (Courtesy of the Montgomery archive.)

Our Main Factory, Cass Ave. and Jones St., Detroit.

One of the most modern and best equipped Piano Plants in the U. S.

We have Three Factories—Detroit and Holly, Mich., and Windsor, Ontario.

THE INCOMPARABLE GRINNELL BROTHERS. For nearly a century, the Grinnell name dominated the piano and retail music business in Detroit. Beginning quietly in 1872 with Ira Grinnell's Ann Arbor–based piano and organ manufacturing business, the company quickly expanded when brother Charles joined the firm. In 1882, they relocated to Detroit and soon achieved incredible growth, establishing manufacturing operations in Detroit and Holly, Michigan, and Windsor, Ontario, Canada.

EVERYTHING IN MUSIC AT GRINNELL'S. In 1908, the Grinnell Brothers built a new headquarters on Woodward Avenue. By then, the company was one of the largest music retailing operations in the country. In addition to shopping for pianos and organs, patrons could browse the incredible selection of sheet music, listen to the latest songs played by company pianists, and shop for the latest in player pianos and piano rolls.

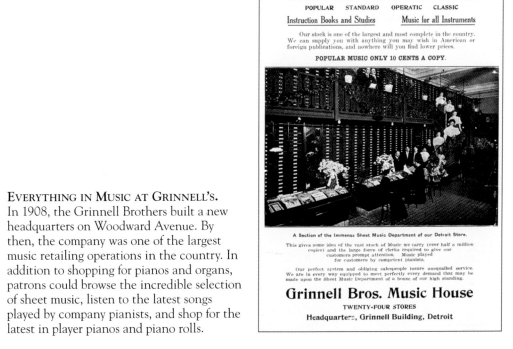

EVERYTHING IN SHEET MUSIC

POPULAR STANDARD OPERATIC CLASSIC

Instruction Books and Studies Music for all Instruments

Our stock is one of the largest and most complete in the country. We can supply you with anything you may wish in American or foreign publications, and nowhere will you find lower prices.

POPULAR MUSIC ONLY 10 CENTS A COPY.

A Section of the Immense Sheet Music Department of our Detroit Store.

This gives some idea of the vast stock of Music we carry (over half a million copies) and the large force of clerks required to give our customers prompt attention. Music played for customers by competent pianists.

Our perfect system and obliging salespeople insure unequalled service. We are in every way equipped to meet perfectly every demand that may be made upon the Sheet Music Department of a house of our high standing.

Grinnell Bros. Music House

TWENTY-FOUR STORES

Headquarters, Grinnell Building, Detroit

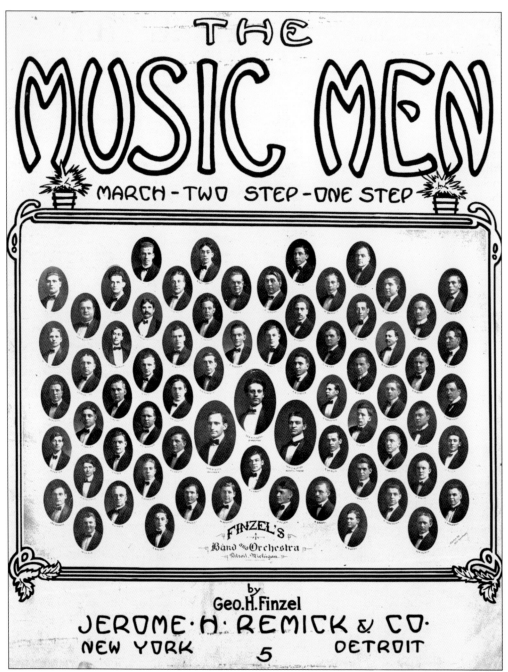

FINZEL'S MUSIC MEN. The Finzel family has been an important part of the music community in Detroit for more than 100 years. Bandleader and composer George Finzel was among the city's earliest writers of ragtime-related material with his "Black Beauty," march and two-step of 1898. Finzel's band was a popular favorite, appearing throughout the city and on the excursion boats for many years.

"WHERE THAT RAG TIME RIVER FLOWS." James Royce, better known as J. R. Shannon, was a composer, songwriter, actor, and *Detroit Free Press* theater critic. Born in Adrian in 1881, he adopted the pen name Shannon early in his career. Most active during the ragtime years, he is considered an important member of the "Tin Pan Alley" school. His compositions include "Too-ra-loo-ra-loo-ral" and the lyrics to "Missouri Waltz."

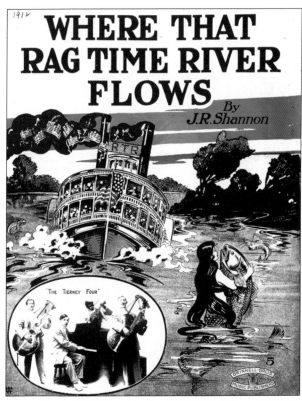

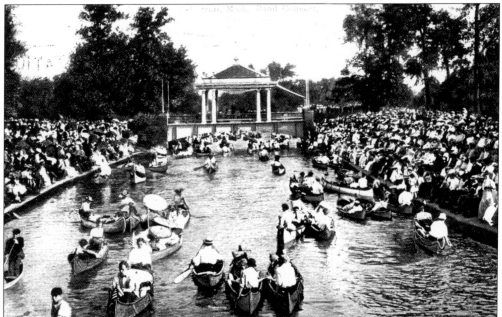

BELLE ISLE BAND CONCERT, C. 1910. Some things never change. Here boaters on Detroit's Belle Isle canoe up the lagoon and clamor around the bandstand, taking in a concert on a quiet night in 1910. Similarly, boaters today are often seen maneuvering crafts along the Detroit River to get within earshot of bands performing at Detroit's Chene Park Amphitheater.

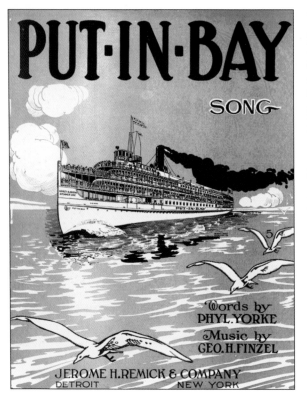

THE *PUT-IN-BAY.* The Detroit excursion boat industry provided local musicians with a dependable source of seasonal work. The 1911 song, "Put-In-Bay," by Phyl York and George Finzel, pays homage to one of Detroit's most popular day-trips. Providing round-trip service from Detroit to Put-In-Bay, a popular island in Lake Erie, the steamer *Put-In-Bay* regularly featured music by the orchestras of Theodore Finney and George Finzel. (Courtesy of the Charlie Rasch collection.)

"**ALL-ABOARD FOR TASHMOO PARK.**" The *Tashmoo* was another of Detroit's popular excursion boats, and it regularly provided passengers with a memorable pleasure trip to Tashmoo Park, a favorite amusement park on nearby Harsen's island. While the *Put-In-Bay* ran south to Lake Erie, the *Tashmoo* ran north to Lake St. Clair. (Courtesy of the Charlie Rasch collection.)

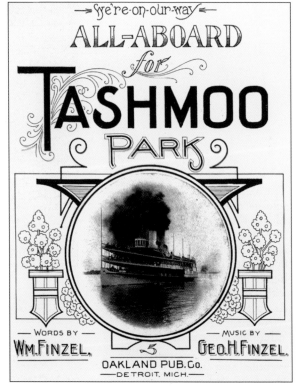

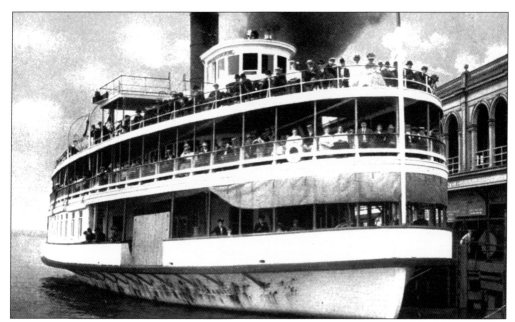

BELLE ISLE AND HARRY P. GUY. Another excursion service served Belle Isle, which featured a five-piece band led by Harry P. Guy. At that time, Guy also worked as a staff arranger for Remick and was instrumental in mentoring the composing efforts of clerk and song demonstrator Henriette Blanke—a professional relationship that put the young woman on her way to a successful career as "America's Waltz Queen."

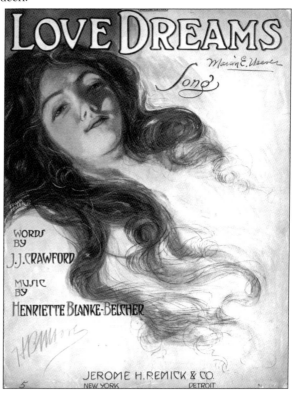

THE WALTZ QUEEN. Under the tutelage of Harry P. Guy, Henriette Blanke began writing music in 1900. Guy's instincts regarding her abilities were well-founded, and her first effort, "Lazarre Waltzes," proved highly successful. Blanke followed with a string of compositions that gained her notice as "one of America's foremost lady composers." While she wrote in many genres, her waltzes were most successful, eventually earning her the title of "America's Waltz Queen."

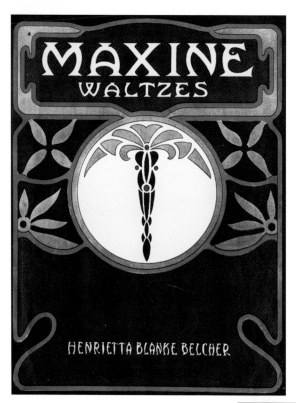

"Maxine Waltzes." In 1905, Henriette Blanke made a society splash by marrying Fred E. Belcher, the vice president of Remick, after which she relocated to New York City. For several years, Henriette continued writing, using the hyphenated version of her name, Blanke-Belcher, and in 1910, wrote the "Maxine Waltzes," dedicated to her daughter, Maxine. After her 1912 divorce, however, the compositions and the fame suddenly ceased.

Charlotte Blake (1885–1979). In city directories, Charlotte Blake's occupation is listed as clerk or pianist. Given the evidence, her job description was loosely drawn—between the years 1903 and 1912, she wrote more than 35 pieces for Remick, including her 1907 ragtime composition "Curly." Initially, Remick obscured her gender by simply using her first initial (C. Blake). By 1906, her name began to appear in full. (Courtesy of the Charlie Rasch collection.)

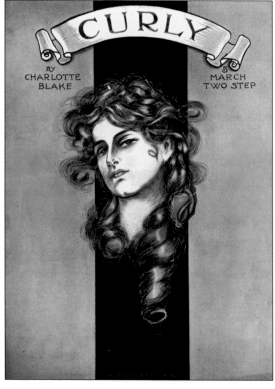

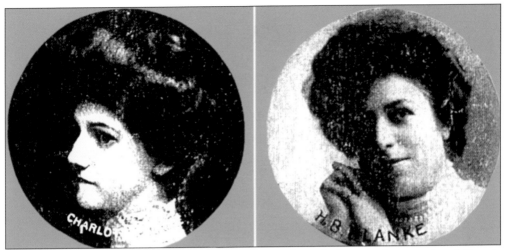

BLAKE AND BLANKE. The two portraits above are the only known photographs of Detroit ragtime era composers Charlotte Blake and Henriette Blanke-Belcher. The images appeared on the cover of a "Star" series popular music folio issued by the Remick Company during the early years of the 20th century. (Courtesy of the Nan Bostick collection.)

"THE GRAVEL RAG." Blake wrote a number of popular piano rags, among them "The Gravel Rag" in 1908. She also wrote marches, waltzes, and songs. Research indicates she resided with her parents and for reasons unknown, produced no known works after 1911. She continued living with her family for many years, never married, and eventually relocated to California, where she died at the age of 94. (Courtesy of the Charlie Rasch collection.)

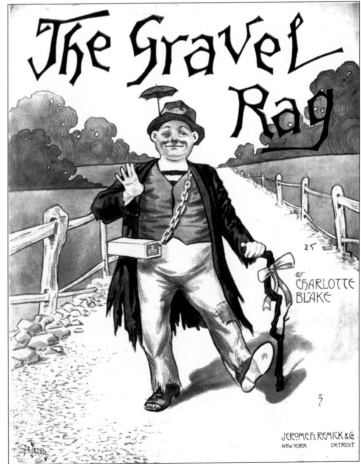

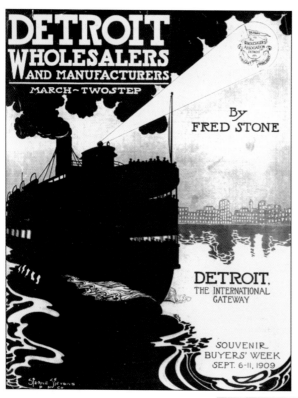

"DETROIT WHOLESALERS AND MANUFACTURERS," 1909. The last-known publication by Detroit ragtime composer Fred S. Stone is a promotional piece entitled "Detroit Wholesalers and Manufacturers," a march and two-step. While not the catchiest title imaginable, it was never intended for sale to the music-buying public. Apparently a giveaway item, it was published on commission of the Wholesalers Association of Detroit for the "Buyers Week" of 1909. (Courtesy of the Montgomery archive.)

"IN DETROIT, LIFE IS WORTH LIVING." Another example of music published for promotional purposes is this 1907 selection "In Detroit, Life Is Worth Living," written by Charles A. Parker and published by the Adcraft Club of Detroit. Most likely presented at a meeting or convention, it holds historical significance as an early promotional effort by a well-known advertising organization still in existence today. (Courtesy of the Montgomery archive.)

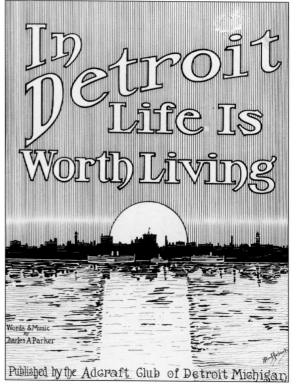

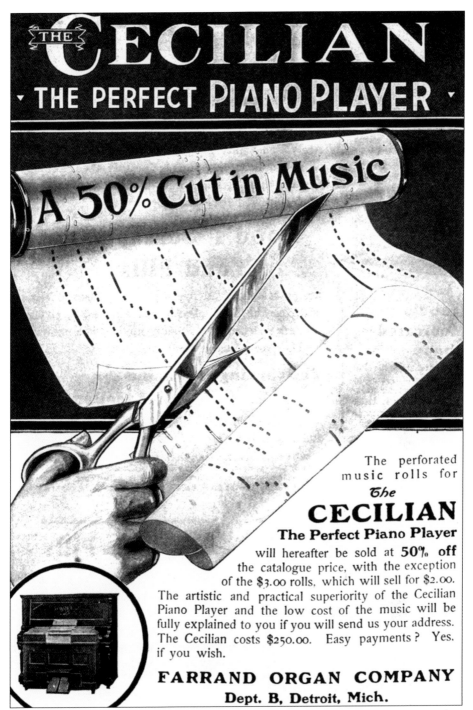

THE CECILIAN
▾ THE PERFECT PIANO PLAYER ▾

A 50% Cut in Music

The perforated music rolls for

The
CECILIAN
The Perfect Piano Player

will hereafter be sold at **50% off** the catalogue price, with the exception of the $3.00 rolls, which will sell for $2.00. The artistic and practical superiority of the Cecilian Piano Player and the low cost of the music will be fully explained to you if you will send us your address. The Cecilian costs $250.00. Easy payments? Yes. if you wish.

FARRAND ORGAN COMPANY
Dept. B, Detroit, Mich.

THE PERFECT PIANO PLAYER. To keep up with changing tastes, many piano and organ manufacturers began making player pianos. In Detroit, the Ferrand Organ Company offered an unusual alternative. Marketed as the "perfect piano player," Ferrand's Cecilian was a boxlike device with legs and pedals. When loaded with a special piano roll and pushed up to a keyboard, this strange device would automatically depress the keys and play the piano.

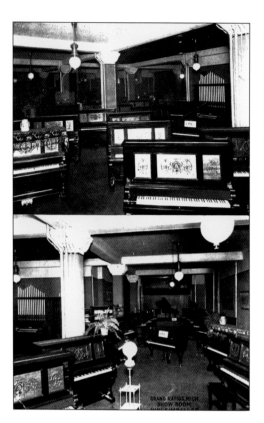

KIMBALL PIANO SHOWROOM, C. 1910.
During the ragtime years, the piano manufacturing industry enjoyed a sales boom that it had never before seen and may never see again. In this *c.* 1910 postcard, the W. W. Kimball Piano Company presents a two-panel view of the wide variety of models available in its Grand Rapids showroom.

WORDEN'S PHONOGRAPH TOP, YPSILANTI.
The early years of the phonograph industry gave birth to some pretty outlandish notions. Worden and Whitman's Phonograph Top purported to spin on one's favorite records and emit some form of sound drawn from the record grooves. No additional information on the device was available at the time of this writing, as the company failed to respond to any of the author's inquiries.

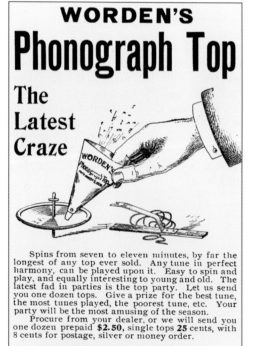

Three

MOTOR KING

During the ragtime years, Detroit went through unprecedented change. The automobile age translated into tremendous growth for the city, and the population swelled with the promise of manufacturing jobs. Start-up car companies were springing up everywhere throughout the region and going out of business almost as quickly. Needless to say, the automobile industry introduced a new subject to popular songs, and the music industry was right there to sing its praises.

During the first 10 years of the 20th century, the Remick Company had become a music industry giant. People everywhere found that they could not live without a phonograph, and the commercial potential of popular songs increased accordingly. Player pianos were in more homes than they ever would be again, and vaudeville stars were making records and appearing in silent films.

During the second decade of the 20th century, the Original Dixieland Jass Band migrated north to Chicago and then to New York, performing a strange sounding music that seemed noisy and raucous. In 1916, when its first record sold one million copies, the strange and raucous music took hold, "jass" changed its name to "jazz," and ragtime began to fade from the public eye.

On the day the United States entered into World War I, Scott Joplin died in a New York sanitarium—the ragtime era was over. In Detroit, manufacturing changed from commercial automobiles to war machines, and Prohibition was about to be embraced by the entire country. While the country would soon bemoan the loss of whiskey and beer, Detroit would suddenly become a bootlegger's dream, with a remedy for Prohibition just across the river in dear old Canada.

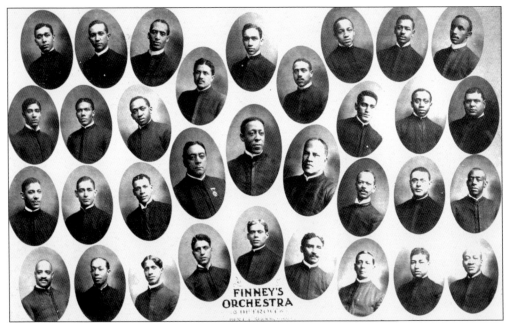

SHOOK, STONE, AND THE FINNEY ORCHESTRA. After Theodore Finney's death, direction of his orchestra shifted between Fred S. Stone and Benjamin Shook. Friction developed, however, when they began operating separate units billed as the Finney Orchestra. The above 1908 photograph shows the Finney Orchestra under Shook. From left to right are (bottom row) Edward Beeler, John Hunter, Deward Robinson, William Pfieffer, Oscar Lindsay, Frank Smith, Charles Scott, Harold Henson, and John Day; (second row) Joseph Buckner, Walter Johnson, Fred Anderson, J. W. Johnson, Benjamin Shook, Frank Mosby, James Hayes, unidentified, and John Ward; (third row) Robert Cruzet, Earl F. Conway, Littleton Smith, Robert Lewis, Oscar Soloman, Clyde B. Hayes, H. W. Adams, and Tom Anderson; (fourth row) Joseph Johnson, Cecil Hayes, Clarence Newby, Leroy Smith, Elmer Jenkins, Oscar Smith, and Samuel Russell. Below is a photograph from the same period, featuring Shook, Stone, and Johnson. (Courtesy of the Arthur LaBrew collection.)

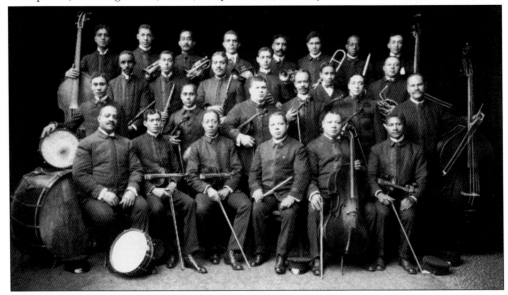

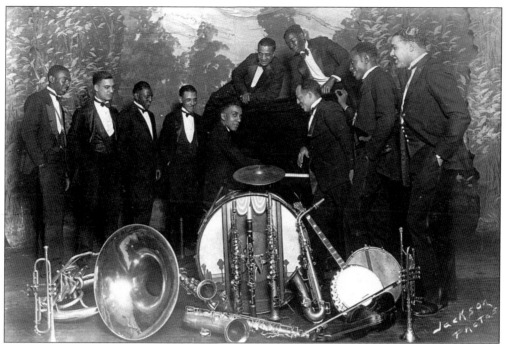

STONE'S ORCHESTRA. The dispute between Fred S. Stone and Benjamin Shook over the right to be billed as Finney's Orchestra resulted in a legal battle that had to be settled in court. The decision handed down allowed Stone to bill his unit as Finney's Original Orchestra, while Shook was allowed to operate his unit as Finney's New Orchestra. According to historians Arthur LaBrew and Nan Bostick, the decision proved unsatisfactory to both parties, and by 1911, Stone's unit was operating as Stone's Orchestra, while Shook's unit was operating as the Ben Shook Orchestra. Following the death of Fred S. Stone in 1912, Charles Stone took command of his brother's operation, continuing to perform as Stone's Orchestra. Here a two-panel photograph card shows Stone's Orchestra under the direction of Charles Stone. (Courtesy of the Hackley Collection.)

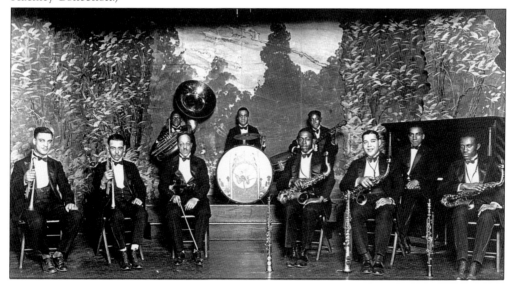

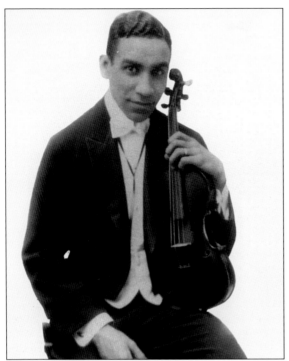

LEROY SMITH (1888–1962). Born in Romeo, violinist and bandleader Leroy Smith grew up in Detroit. His father was employed as a cornetist for Finney's Orchestra, and in time, Leroy would also become a member. Classically trained, he was slow to warm to the improvisational nature of jazz, and although his records feature a jazz element, they often employ a more symphonic approach to the popular music form. (Courtesy of the Hackley Collection.)

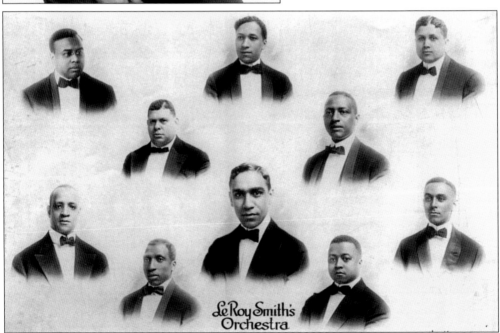

LEROY SMITH'S ORCHESTRA. After his experience with the Finney Orchestra, the young Leroy Smith founded his own orchestra and booked units of varying size throughout the region. From 1914 through 1919, the Leroy Smith Orchestra—sometimes numbering as many as 16 pieces—enjoyed a five-year engagement at Detroit's Pier Ballroom. Pictured is a series of portrait-style renderings featuring an early, 10-piece configuration of Leroy Smith's Orchestra. (Courtesy of the Hackley Collection.)

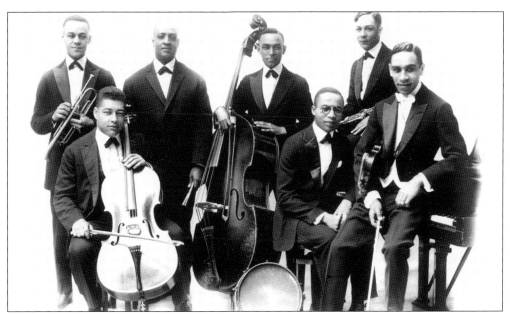

LEROY SMITH'S ORCHESTRA, 1914. Leroy Smith's Orchestra, along with those of Finney, Finzel, and Stone, were best regarded as a "society" orchestra. In smaller units, sometimes considered a salon orchestra, capable of rendering the latest music best suited to dancing and dining. During the ragtime years and early days of the jazz age, dances like the foxtrot, one-step, and two-step were rivaled in popularity by the waltz, tango, and animal dances, which included the turkey trot, grizzly bear, and kangaroo hop. The two studio portraits of the Leroy Smith Orchestra featured on this page date from a session in 1914. Seen in the above photograph, from left to right, are (first row) Harold Henson, Harry Brooks, and Leroy Smith; (second row) Stanley Peters, Ed Beeler, Fred Peters, and Emerson "Geechie" Harper. The bottom photograph, with members gathered around Smith and Brooks, features the same personnel. (Courtesy of the Hackley Collection.)

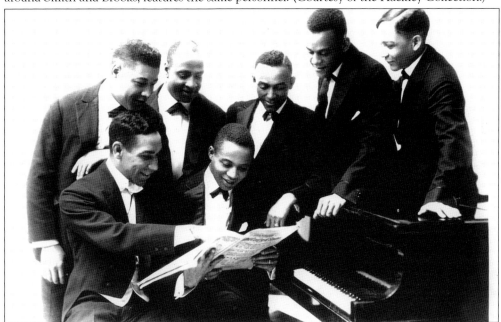

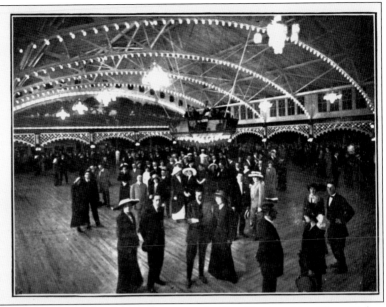

THE **PIER**

Detroits
Finest
Ballroom

Dancing Every
Evening

POSITIVELY NO
LIQUOR
CONNECTIONS

PIER BALLROOM. One of the earliest Detroit ballrooms was the Pier. Designed by Albert Kahn, the ballroom was located at Detroit's Electric Park, a popular amusement park of the time that stood on the mainland near Belle Isle. The photograph card, postmarked 1913, shows the voluminous dance floor. Although the card predates Prohibition in Michigan by five years, the card states: "Positively no liquor connections."

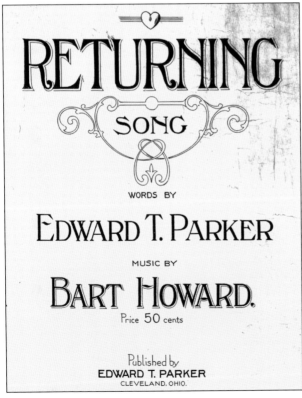

RETURNING

SONG

WORDS BY

EDWARD T. PARKER

MUSIC BY

BART HOWARD.

Price 50 cents

Published by
EDWARD T. PARKER
CLEVELAND, OHIO.

BART HOWARD. Migrating to Detroit from Ohio in 1914, locals called him the king of ragtime pianists. Eccentric and aloof, he hired a mysterious Dr. Alexander to cut the webbing between his fingers to extend his reach. Between performances, he wore gloves with a marble between each finger. His only published work is "Returning," from 1912. He died in 1929, left no photographs, and is buried in an unmarked grave. (Courtesy of the Montgomery archive.)

THE COPY BOY AND THE BANK CLERK. In 1916, two young and somewhat unlikely songwriters converged to write a hit song with the rather lengthy name, "(They Made it Twice as Nice as Paradise) and They Called it Dixieland." The writers were Richard Whiting (1891–1938), a pianist who began his career at Remick working as a copy boy, and Raymond Egan (1890–1952), a bank clerk with a habit of writing lyrics and spending his lunch hours at the Remick Company offices. While Whiting had written several songs for Remick, this was his first collaboration with Egan. The two writers would produce many hits together, including "Ain't We Got Fun," "Japanese Sandman," and "Sleepy Time Gal." In time, they would establish prolific songwriting careers, working together and apart, and eventually gain recognition in the songwriters hall of fame.

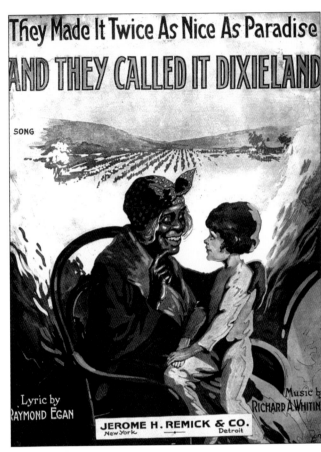

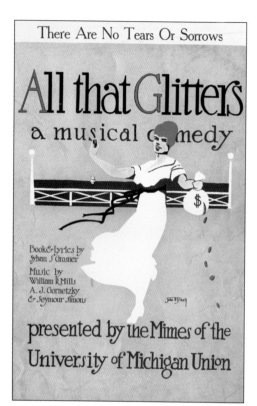

There Are No Tears Or Sorrows

All that Glitters
a musical comedy

Book & Lyrics by
Sylvan S Grosner
Music by
William R Mills
A. J. Gornetzky
& Seymour Simons

presented by the Mimes of the
University of Michigan Union

ALL THAT GLITTERS. During the second decade of the 20th century, many of the next generation of America's songwriters were busy studying at the University of Michigan. Several were able to sharpen their skills writing for productions staged by the college. "All That Glitters" featured songs by Detroit songwriters Seymour Simons and A. J. Gornetzky (who later changed his name to Jay Gorney). Other University of Michigan songwriters include Edward Heyman and Jack Yellen.

SEYMOUR SIMONS (1896–1949). While studying engineering at the University of Michigan, Simons wrote music for several reviews staged by the university union. After graduation, he worked briefly as an engineer for Packard Motors before entering military service during World War I. On his return to civilian life, Simons met popular singer Nora Bayes and, within a short time, began writing complete scores for her stage productions. (Courtesy of the Rudy Simons collection.)

GENE BUCK (1885–1957). The name Gene Buck appeared on sheet music for decades, but in two of the most unrelated capacities imaginable. Born and raised in Detroit, Buck studied at the Detroit Art School and began his career designing and illustrating sheet music covers. Hampered by a severe vision ailment, Buck was eventually forced to make a career change. Fortunately, he had a love of the theater and a penchant for writing lyrics, and by midway through the second decade of the 20th century, he was working on Broadway writing for shows and providing lyrics to the songs. In his life he achieved fame as an artist, writer, director, producer, and eventually, president of ASCAP (American Society of Composers, Authors and Publishers). Irving Berlin's 1911 ragtime song, "Everybody's Doin' It, Now" (right), features cover art by Buck (as does Henriette Blanke's "Maxine Waltzes"), while the song below, "List'ning on Some Radio," from 1922, features his lyrics.

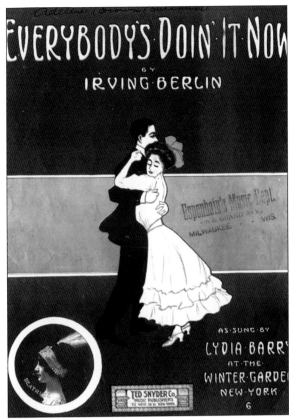

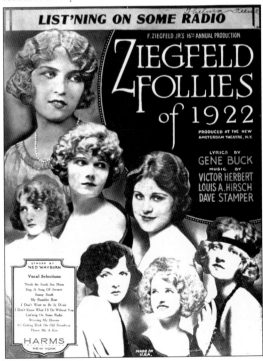

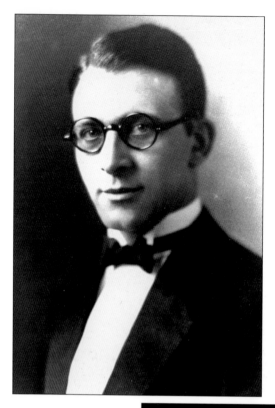

JEAN GOLDKETTE (1893–1962). Born in Greece in 1893, pianist John Jean Goldkette spent much of his early life in Europe and studied at the prestigious Moscow Music Conservatory before immigrating to the United States in 1910. While he made a handful of classical piano recordings and at least one piano roll, he ultimately gained fame as a bandleader, promoter, and booking agent in Detroit. (Courtesy of the Duncan Schiedt collection.)

"LA SEDUCCION." Prior to relocating to Detroit, Goldkette tried, unsuccessfully, to make a living as a concert pianist. Working in and around Chicago, Goldkette found more lucrative work performing with dance bands. In 1916, he made a piano roll of "La Seduccion," a 1913 composition by Noceti. The roll was issued by Recordo (6130) and Imperial (55930). No other Goldkette rolls are known. (Courtesy of the Montgomery archive.)

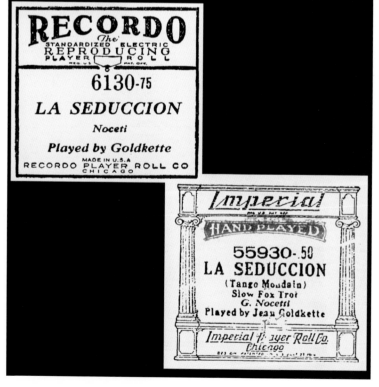

GOLDKETTE AS ACCOMPANIST. During the years prior to coming to Detroit, Goldkette appeared on a few recordings as a piano accompanist, backing up other artists. On the rare example at right, Goldkette accompanies saxophonist Duane Sawyer performing "Going Up," on Gennett Record 8512. The duo also appears on the reverse side performing "Sinbad." (Courtesy of the Josh Duffee collection.)

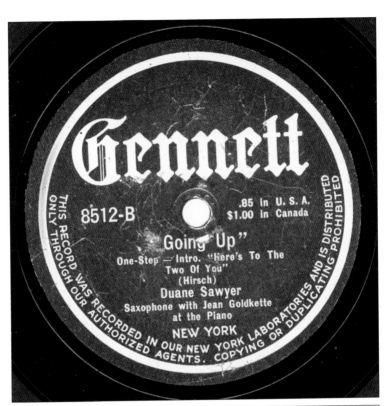

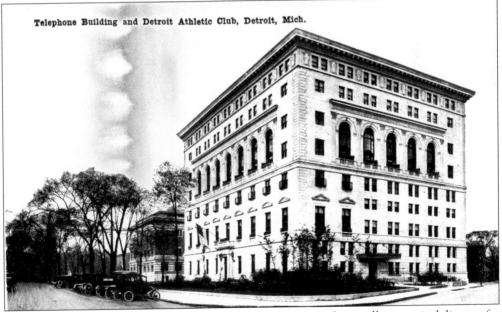

DETROIT ATHLETIC CLUB. Goldkette first came to Detroit professionally as musical director for the Detroit Athletic Club. Established in 1887, the exclusive club included among its members some of the most successful automobile barons and entrepreneurs in Detroit. The club first occupied its current residence in 1915, where Goldkette led a band and supervised the musical activities at the club for almost 15 years

I Didn't Raise My Ford to be A Jitney

BY THE SAME COMPOSER

The Street Car Rag (Song)
Don't You Love Your Baby No More?
Neutral is My Middle Name
I Didn't Raise My Ford to
be A Jitney

That's Cow
The Monkey Jubilee
You Can't Afford to Marry
if You Can't Afford A Ford
Everybody Loves Me but You

WORDS AND MUSIC
BY
JACK FROST

Frank K. Root & Co.
CHICAGO-NEW YORK

DETROIT'S LOVE STORY FOR AMERICA. People today may not know that a jitney is an outmoded term for a bus. "I Didn't Raise my Ford to be a Jitney" (left), recalls an era when car owners were often victimized by carless friends requesting a ride in their new Ford. The automobile became a popular subject in songs of the second and third decades of the 20th century, and few models and makes were exempt from the craze. While most of the songs (and the automobiles they heralded) are long forgotten, some have survived the test of time. Perhaps the most famous of the car songs is the 1905 classic, "In My Merry Oldsmobile." One of the most bizarre offerings of the automobile song genre is undoubtedly "The Love Story of the Packard and the Ford" (below), a 1915 musical saga by Harold Atteridge and Harry Carroll.

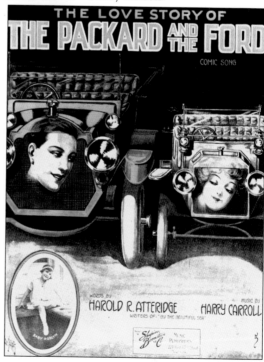

THE LOVE STORY OF
THE PACKARD AND THE FORD
COMIC SONG

WORDS BY
HAROLD R. ATTERIDGE
WRITERS OF "BY THE BEAUTIFUL SEA"

MUSIC BY
HARRY CARROLL

"I Want to Go Back to Michigan (Down on the Farm)." While Detroit was fast becoming an industrial giant at the hands of the automobile industry, Michigan was still predominantly thought of as an agricultural region. This Irving Berlin hit song of 1914 sings the praises of a rural and pastoral Michigan that is fast becoming hard to find in the present day.

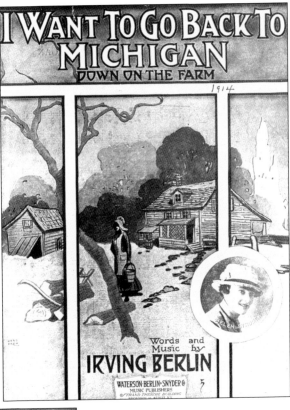

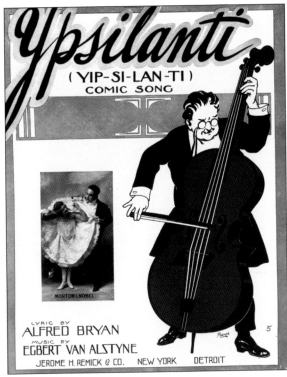

"Ypsilanti." In 1915, songwriters Alfred Bryan and Egbert Van Alstyne put the small Michigan college town on the map with a comic song of the same name. Published by Jerome Remick, it was a reasonable hit, despite the fact the somewhat painful lyric included mention of an "auntie" who lived in a "shanty" in Ypsilanti. (Courtesy of the Montgomery archive.)

55

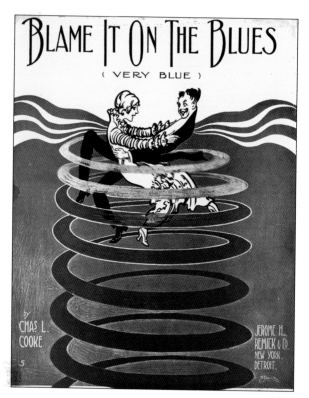

DOC COOKE. African American composer Charles L. Cooke was a unique individual. After obtaining a doctorate from the Chicago College of Music, he worked as a conductor, organized jazz bands, and was staff arranger for RKO and Radio City. In Detroit, between 1909 and 1921, he performed with the bands of Fred S. Stone and Benjamin Shook, led his own band, and arranged and composed music, including the 1914 rag, "Blame It on the Blues."

DUPLEX PHONOGRAPH, KALAMAZOO. Even in the earliest years of the recording industry, manufacturers were competitively searching for methods to improve sound recording and sound reproduction. One bizarre attempt is featured in this 1906 advertisement for the Duplex phonograph. Outfitted with two large horns, the Duplex promised a "purer, sweeter" tone and "double the volume of sound!"

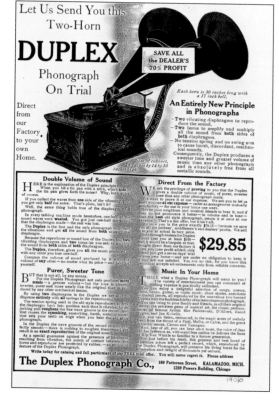

Four

WOLVERINE BLUES

By 1920, the jazz age had fully taken hold in America. The popularity of the Original Dixieland Jazz Band (ODJB) recordings prompted record companies to bring many other small group jazz bands to the marketplace, including the Original Memphis Five, the Georgians, and Edison's Georgia Melodians. At the same time, the larger bands, like Paul Whiteman's Orchestra, were quickly becoming popular throughout the country, offering a more subdued and dance-oriented, "symphonic" approach to jazz.

By this time, most of Victor's coveted phonograph and recording patents had expired, and the door was suddenly open—it seemed as though every furniture and piano manufacturer in America was entering into the industry, making phonographs and introducing their own record labels to the marketplace. Some would become very large and successful, others would scarcely survive. Most would be gone by 1930.

In Richmond, Indiana, Gennett Records, a subsidiary of the Starr Piano Company, inadvertently made some of the most important (and rarest) records in jazz history. In 1923, they recorded the New Orleans Rhythm Kings and King Oliver's Creole Jazz Band, two bands from New Orleans becoming popular in Chicago. King Oliver's records introduced the world to a young cornet player named Louis Armstrong.

A year later, Gennett's recordings by the Wolverine Orchestra introduced the world to the young cornetist, Bix Beiderbecke. In his short life, Beiderbecke would create some of the most unforgettable recordings of the jazz age—a recording odyssey that began in Richmond, Indiana, and led him next to Detroit.

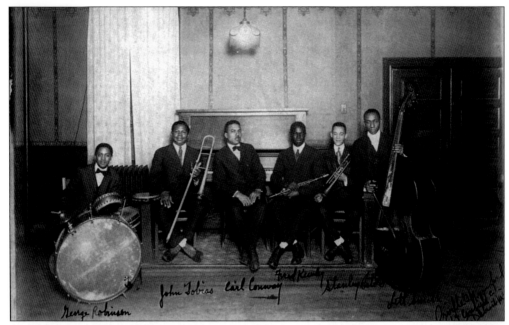

ALABAMA JASS BAND. Perhaps it was good marketing to name a band after a southern location during the early years of jass. Otherwise, there is little reason for these Detroit musicians to call themselves the Alabama Jass Band. Photographed at the Elwood Café in 1920, the musicians are identified as, from left to right, George Robinson, John Tobias, Earl Conway, Fred Kewley, Stanley Peters, and Littleton (Litt) Smith. (Courtesy of the Hackley Collection.)

DAVE WILBORN, 1920. Wearing his first pair of long pants, a 16-year-old Dave Wilborn poses with his banjo. Born in 1904 in Springfield, Ohio, Wilborn performed with Cecil Scott's Symphonic Syncopaters and William McKinney's Synco Jazz Band on his way to becoming an indispensable member of McKinney's Cotton Pickers. In addition to appearing on the band's many recordings, he also recorded with Louis Armstrong and Jean Goldkette. (Courtesy of the Charlie Rasch collection.)

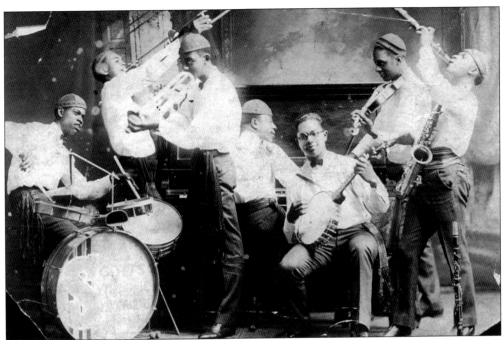

SCOTT'S SYMPHONIC SYNCOPATERS. Dave Wilborn is seen participating in an early photograph session for Scott's Symphonic Syncopaters. Led by jazz legend Cecil Scott, the band was formed in Springfield, Ohio, and competed with William McKinney's Synco Jazz Band. McKinney's band would eventually evolve into the Cotton Pickers, for which Wilborn would later become a core member. Cecil Scott's band would go through several personnel changes, eventually recording as Lloyd Scott and his orchestra and Cecil Scott's Bright Boys. Scott eventually rounded out his career as a successful sideman in several classic bands of the big band era. Seen in the above photograph from left to right are Lloyd Scott (drums), Earl Horne (trombone), Gus McClung (trumpet), Don Frye (piano), Dave Wilborn (banjo), Buddy Burton (violin), and Cecil Scott (reeds). In the bottom photograph are, from left to right, Horne, Lloyd Scott, McClung, Wilborn, Burton, Frye, and Cecil Scott. (Courtesy of the Hackley Collection.)

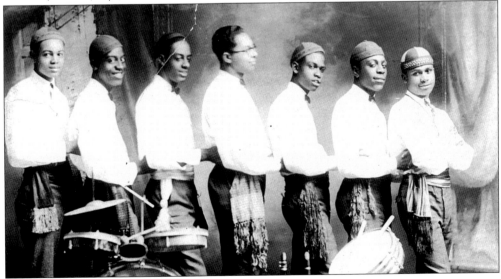

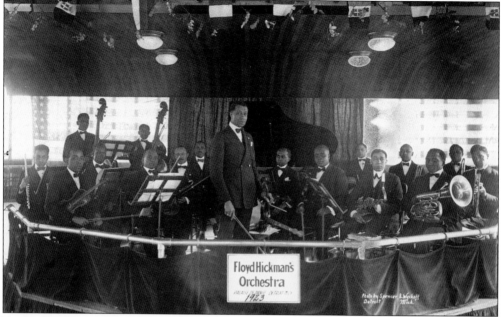

FLOYD HICKMAN ORCHESTRA. Seen here is Detroit's Palais De Danse in 1923. From left to right are Norvel Morton (flute), Ray Scott (violin), Clyde Hayes (bass), Fred Kewley (clarinet), Littleton Smith (bass), Harry Jordan (violin), Harold Henson (alto sax), Wen Talbert (piano), Floyd Hickman (leader), Orld (Orlando?) Harris (violin), Al Robinson (violin), George Massey (drums), Joe Johnson (sax), Oscar Smith (trumpet), Ben Mitchell (baritone), John Tobias (trombone), and Joe Buckner (trumpet). (Courtesy of the Hackley Collection.)

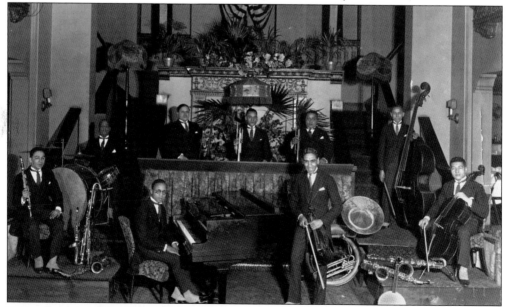

LEROY SMITH IN NEW YORK. Playing for more than five years at Detroit's Pier Ballroom, Leroy Smith and his orchestra had benefited greatly from their popularity and reputation. By the early 1920s, the band sought to gain national attention and moved on to New York City, where they soon became the house band at Connie's Inn. (Courtesy of the Hackley Collection.)

LET'S TAKE THE BAND HOME

The tunes you have just danced to played by

LeRoy Smith's Dance Orchestra

on the

BLU-○DISC RECORDS

GET THEM AT THE CIGAR COUNTER

LEROY SMITH AND BLU-DISC RECORDS. In 1924, Leroy Smith and his orchestra appeared in a stage production in New York, and the newly formed Blu-Disc Record Company recorded two of the selections the band introduced in the show. The record was available at the theater's cigar counter, and postcard-sized fliers (above) were provided to help generate sales. Unfortunately, it appears this was the only place Blu-Disc records could be purchased. As a result, the Blu-Disc Record Company may hold the dubious distinction of being the shortest-lived record company in history. Its catalog seems to begin and end in the month of December 1924. Supposedly, the company issued the records listed on the flier at right (though some have never been found, and there is doubt as to whether they were all actually pressed). Needless to say, Blu-Disc records are among the rarest known. (Courtesy of the Montgomery archive.)

LISTEN TO THIS

BLU-DISC

RECORDS

DECEMBER RELEASES

Featuring **LEROY SMITH'S DANCE ORCHESTRA**

1001	MORNING (Won't You Ever Come Round) Fox Trot	Leroy Smith & His Dance Orch.
	STOP AND LISTEN Fox Trot	Leroy Smith & His Dance Orch.
1002	RAINY NIGHTS Fox Trot	The Washingtonians
	CHOO CHOO Fox Trot	The Washingtonians
1003	OH! HOW I LOVE MY DARLING Novelty Fox Trot, Vocal Chorus Sonny Greer and The D C'ns.	
	DEACON JAZZ Novelty Fox Trot	Jo. Trent & The D C'ns.
1004	NASHVILLE NIGHTINGALE Fox Trot	Duke Ellingtons Orch.
	ROSE MARIE Fox Trot	Duke Ellingtons Orch
1005	I WANT TO BE HAPPY Fox Trot	The Blu-Disc Orch.
	TEA FOR TWO Fox Trot	The Blu-Disc Orch.
1006	JUNE NIGHT Fox Trot	The Blu-Disc Orch.
	IT HAD TO BE YOU Fox Trot	The Blu-Disc Orch.
1007	ITS GONNA BE A COLD, COLD WINTER (So Get Another Place to Stay) Vocal Blues Alberta Prime	
	PARLOR SOCIAL DE LUXE Vocal Novelty	Alberta Prime- Sonny Greer
1008	FOLLOW THE SWALLOW Tenor Solo	Irving Post
	PUT AWAY A LITTLE RAY OF GOLDEN SUNSHINE (For a Rainy Day) Tenor Solo Irving Post	
1009	OH! YOU CAN'T FOOL AN OLD HOSS FLY Comedy Solo	Arthur Hall
	HOW DO YOU DO Vocal Duet	Arthur Hall–John Ryan

Selections by

Paul Robeson Star "All Gods Chillen Got Wings"

Fred Weaver "Clef Club" Favorite

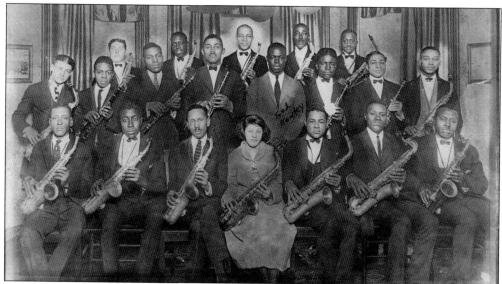

FRED KEWLEY AND HIS STUDENTS, 1923. Fred Kewley stands (center) with his saxophone and clarinet students in a 1923 photograph, most likely taken in his home. Kewley was the foster father of Detroit jazz musicians Ted and Milt Buckner. The Buckner brothers were from St. Louis and orphaned at an early age. They came to Detroit in 1924, and Kewley raised them and provided their musical training. (Courtesy of the Hackley Collection.)

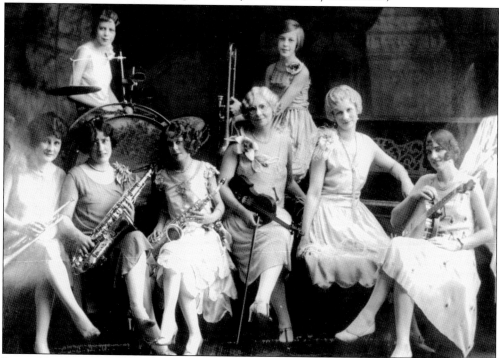

JAZZIN' BABIES BALL. The post–World War I years and the advent of women suffrage ushered in a new age for women. While the ragtime years had a healthy share of ragtime women composers, during the jazz age, women began to make an impact as performing musicians as well. This unknown band of Michigan "jazz babies" looks to feature several generations of musical talent.

BLUES IN BENTON HARBOR. Founded in Benton Harbor in 1902, Michigan's House of David religious sect eschewed haircuts, practiced vegetarianism, and espoused a strict regimen of celibacy. They also ran a popular amusement park. However, scandal erupted when 13 women testified to having sexual relations with founder Benjamin Purnell. The music industry responded with "The House of David Blues," in 1923, complete with a cover characterization of long-bearded "jazzomanics." (Courtesy of the Montgomery archive.)

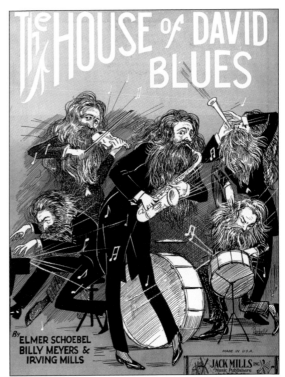

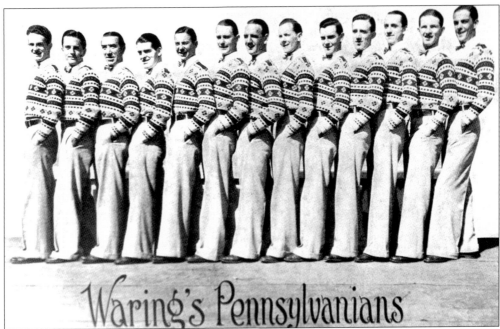

WARING'S PENNSYLVANIANS. While many remember Fred Waring and his Pennsylvanians, few are aware the band from Tryone, Pennsylvania, leaped to stardom through the power of radio in Detroit. In 1922, the band was in Ann Arbor performing at an annual J-Hop, when they were asked to perform live on radio station WWJ. Within months, the exposure led to a contract with Victor records and a string of hit records.

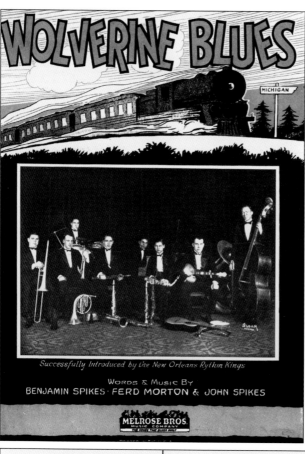

Successfully Introduced by the New Orleans Rythm Kings

WOLVERINE BLUES

WORDS & MUSIC BY
BENJAMIN SPIKES · FERD MORTON & JOHN SPIKES

MELROSE BROS.
MUSIC COMPANY

WOLVERINE BLUES. With a lyric that declares, "I'll be dancing back in Lansing," Ferd "Jelly Roll" Morton's "Wolverine Blues" has remained a jazz standard for more than 80 years. Recorded by many bands, including Detroit's Oriole Terrace Orchestra, the most historically significant is probably the 1923 Gennett Record pressing by the New Orleans Rhythm Kings (NORK). While Morton long insisted that the song was written for a close friend who owned the Wolverine Barbershop in Detroit, historians and jazz enthusiasts had never experienced a great deal of luck identifying the location of the establishment. A recent discovery by historian and archivist Mike Montgomery has finally cleared up the mystery. The advertisement, below (from an early 1930s Detroit theatrical program) may be the only existing reference to the famous jazz song's namesake. (Courtesy of the Montgomery archive.)

ISHAM JONES (1894–1956). Songwriter and bandleader Isham Jones grew up in Saginaw and learned to play the violin at an early age. A gifted multi-instrumentalist and writer, Jones was the leader of his own band by the time he was 18 years old. Establishing himself in Chicago, Jones became best known for his saxophone work and obtained a lucrative recording contract with Brunswick Records. His image began to be commonplace on sheet music covers throughout the 1920s, and his reputation as a successful songwriter led to a partnership in the Milton Weil Music Publishing firm. During the 1920s and 1930s, Jones also recorded for Victor and Decca, but is best remembered, today, as a songwriter, penning several standards, including "Swingin' Down the Lane," "Spain," "On the Alamo," "I'll See You In My Dreams," and "It Had to Be You." The cartoon illustration of Jones (below) appeared in the February 1924 issue of the *Talking Machine Journal*, a record industry trade publication. (Right, courtesy of the Charlie Rasch collection; below, courtesy of the Montgomery archive.)

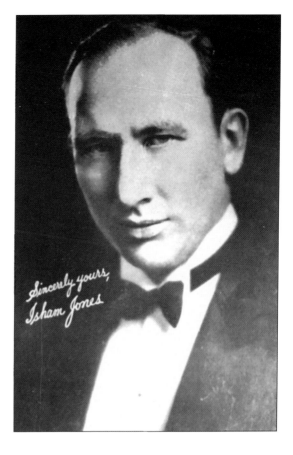

Isham Jones

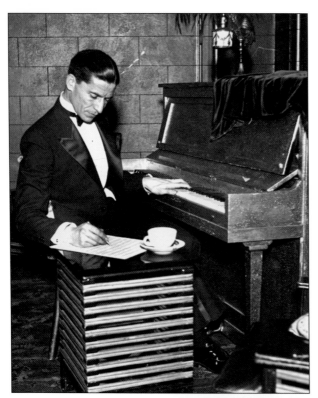

SIMONS AND GOLDKETTE REMEMBER. Gaining a foothold on Tin Pan Alley through his work with Nora Bayes, Seymour Simons began a songwriting career that produced several hit songs. One of his earliest successes was "Remember," recorded in Detroit by the Jean Goldkette Orchestra and featuring Simons as the vocalist. To accommodate recording from a remote location, Victor Records created a makeshift studio in the Detroit Athletic Club. (Courtesy of the Rudy Simons collection.)

TWO "REMEMBER'S." Shortly after Simons composed his 1924 song, "Remember," he received a letter from Irving Berlin, who wanted to use the title for his own song. Simons had no objections, but suggested that Berlin could avoid similar situations by prefixing his songs with his name. Hence, Berlin's "Remember," became "Irving Berlin's Remember." Berlin thanked Simons and applied the prefix to his songs from that day forward.

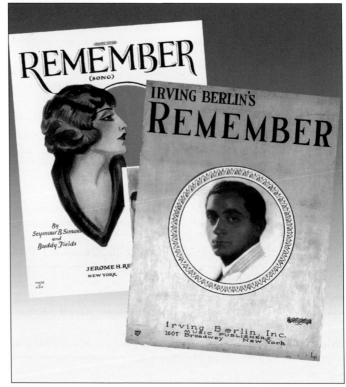

PETE BONTSEMA AND HIS HOTEL TULLER ORCHESTRA. Detroit musician and bandleader Pete Bontsema led a house band in the Arabian Room of the Hotel Tuller. The band is pictured at right on the cover of "Holding Hands," in 1923, published by Charles E. Roat of Battle Creek. Roat (1872–1936) was a Michigan composer and ran a small publishing company for many years out of his music store in Battle Creek. According to advertisements of the period, the Charles E. Roat Music Company (located at 60 West Michigan Avenue) specialized in pianos, Victrolas, sheet music, electric refrigerators, and oil burners—talk about one-stop shopping! Pete Bontsema's Hotel Tuller Orchestra recorded "Holding Hands" on the Gennett label (below). (Right, courtesy of the Montgomery archive; below, courtesy of the Hester collection.)

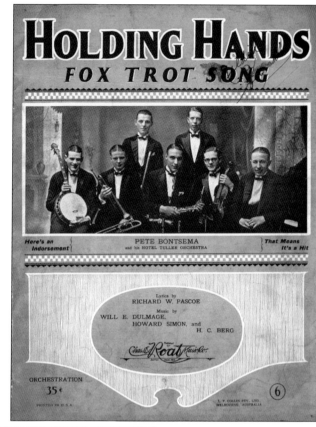

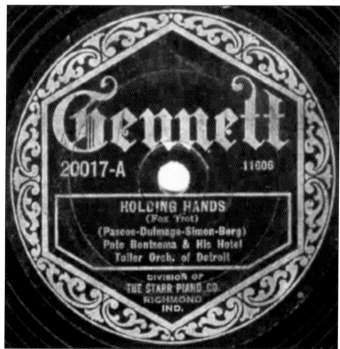

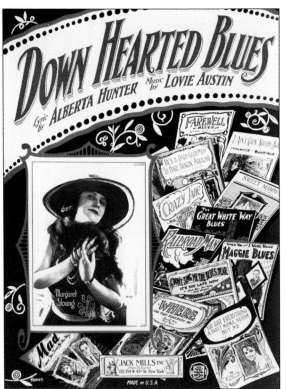

MARGARET YOUNG (1891–1969). Popular Detroit-born recording artist Margaret Young appears on the cover of "Down Hearted Blues," from 1923, by Alberta Hunter and Lovie Austin. Young began her career locally, eventually becoming a major vaudeville entertainer. During the 1920s, she recorded for Victor and became a signature artist for Brunswick. Her sister Eleanore was the wife of Detroit songwriter Richard Whiting, and mother of singer Margaret Whiting. (Courtesy of the Charlie Rasch collection.)

BRUNSWICK PRESSING PLANT, MUSKEGON. In 1923, the Brunswick-Balke-Collender Company opened a record pressing plant in Muskegon. When Brunswick acquired Vocalion Records in 1925, work at the plant increased substantially, accommodating the pressing needs of both labels. When the Depression forced Brunswick to sell its recording operations in 1930, the plant was used to press Decca-based Champion records. Pressing operations at the Muskegon plant ceased altogether in the mid-1930s.

Record Delivery Envelopes

PRINTED WITH YOUR OWN NAME

Every time an envelope leaves your store, make it take your name outside to bring in new trade. The advertising more than pays for the envelope.

The button and cord fastener means speed in wrapping—you can wait on more people. The heavy paper means protection to the records.

Write for samples and prices to

LEWIS C. FRANK

653 BOOK BLDG. - DETROIT

RECORD DELIVERY ENVELOPES. Record stores, department stores, cigar stores, and even drugstores sold records in the early years of the phonograph record industry. Each record company's distribution varied greatly, and the most common labels found at the store were Victor, Columbia, and Brunswick. The Lewis C. Frank Company of Detroit was a frequent advertiser in the phonograph industry trade magazines, introducing sturdy record envelopes, preprinted to identify the record retailer. It was an inexpensive and popular advertising notion that caught on with retailers everywhere, as evidenced by the examples (below) from the Peoples Outfitting Company and Crowley-Milner and Company, two major Detroit department stores, and the Webber-Ashworth Company of Cadillac.

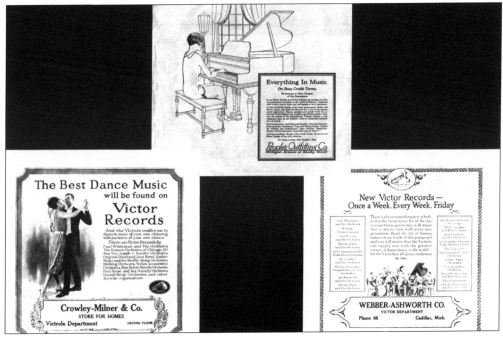

HUDSON RECORDS. In 1924, Detroit's J. L. Hudson Company introduced its own record label. Produced by the Bridgeport Die and Machine (BD&M) Company, the records used masters leased from the Emerson Record catalog. While they featured some jazz selections, their extreme rarity has prevented compilation of a complete discography. BD&M filed for bankruptcy in 1925. No Hudson records were issued after that time. (Courtesy of the Montgomery archive.)

ADVERTISING POCKET MIRROR. Advertising giveaway knickknacks are still around, but they were certainly of a higher quality in the marketing schemes of old. Here a "handy" pocket mirror, from late in the second decade of the 20th century, advertises the Grinnell Brother's Music House. Constructed of base metals, glass, and celluloid, the nearly 100-year-old artifact ages with a dignity lost in the modern age of mass-produced plastics.

Five

Breezin' Along with the Breeze

By the mid-1920s, Detroit was home to several nationally known recording bands, including Finzel's Arcadia Orchestra of Detroit, Russo and Fiorito's Oriole Terrace Orchestra, and Jean Goldkette's Book-Cadillac Hotel Orchestra. While no major record label maintained permanent recording facilities in the city, Victor and Okeh had accommodated some local recording sessions by setting up temporary facilities. However, both labels, along with all the others, preferred recording in their permanent studio facilities, primarily in New York or Chicago.

Dance halls, ballrooms, and theaters were thriving in Detroit, and out in the hinterlands, touring bands were finding work in ballrooms and pavilions in small towns like Walled Lake, Brighton, and New Hudson—among them, Jean Goldkette's Blue Lantern Ballroom at Island Lake. Detroit's new wave of songwriters, including Gerald Marks, Seymour Simons, and Richard Whiting, were churning out hits, and the Remick Company was thriving, maintaining major offices in Detroit and New York.

To ward off the sobering affects of Prohibition, many Detroit automobile garages quietly offered patrons the service of customizing cars with a false bottom. The clever remodeling job created a handy storage space between the car's floor and undercarriage, guaranteed to escape the scrutiny of customs officials stationed at the tunnel (and soon to be completed bridge) to Canada.

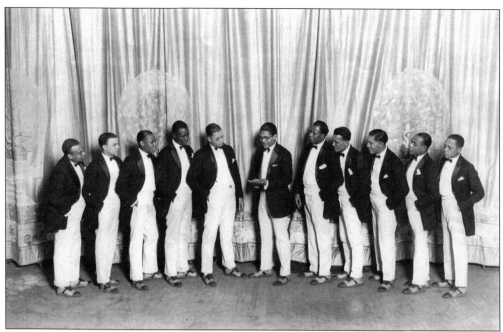

EARL WALTON ORCHESTRA. Detroit bandleader Earl Walton stands center stage with his band in front of the curtain at Detroit's Palais De Danse in 1925. From left to right are Robert Bush, Earl Foley, Claude Calloway, Fred Kewley, Al Goines, Earl Walton, John Tobias, Clyde Hayes, George Robinson, Charles Gaines, and Harry Owens. (Courtesy of the Hackley Collection.)

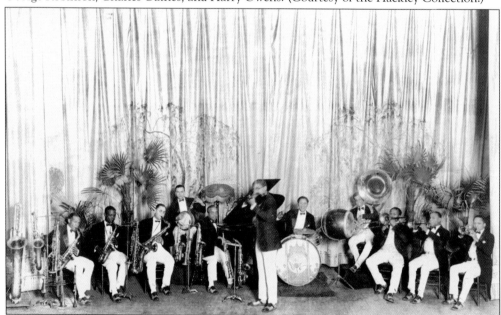

EARL WALTON BAND IN ACTION. In a photograph from the same session as above, the Earl Walton Orchestra poses for an action photograph at the Palais De Danse in 1925. From left to right are Claude Calloway, Fred Kewley, Al Goines, Earl Foley, Robert Bush, Earl Walton, George Robinson, Clyde Hayes, John Tobias, Charles Gaines, and Harry Owens. (Courtesy of the Hackley Collection.)

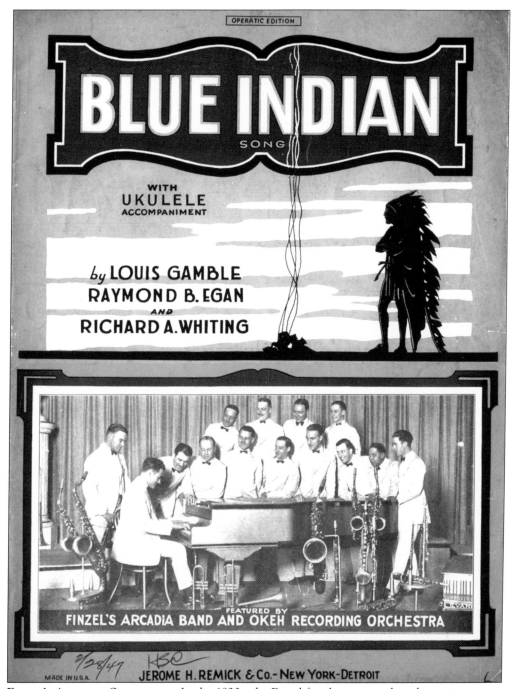

FINZEL'S ARCADIA ORCHESTRA. In the 1920s, the Finzel family continued to play an important role in the Detroit music scene with William Finzel leading the house band at the Arcadia Ballroom. Commanding a strong regional following, the band quickly came to the attention of Okeh Records. Headed by the General Phonograph Company of New York, Okeh was one of the larger recording companies in the industry.

"LAFF IT OFF," FINZEL'S ARCADIA ORCHESTRA. Okeh brought in field equipment to record the band's single "Laff It Off." While field recording had become common in the 1920s, the usual process did not include a live audience. Discographer Brian Rust notes that *Talking Machine World*, of February 1925, states the record was made at Detroit's Arcadia Ballroom in front of thousands of patrons—a rare occurrence. (Courtesy of the Hester collection.)

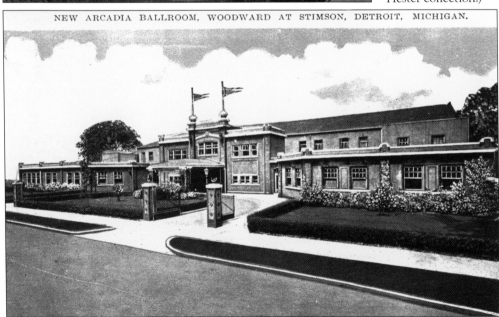

THE NEW ARCADIA BALLROOM. Located directly across the street from the Bonstelle theater, the New Arcadia Ballroom was one of the more palatial and distinguished of the Detroit Ballrooms. In the early 1920s, admission was 15¢ for ladies and 25¢ for men. Billed as the "Most beautiful ballroom in America," it stood at the corners of Woodward Avenue and Stimson Street and is now a vacant lot.

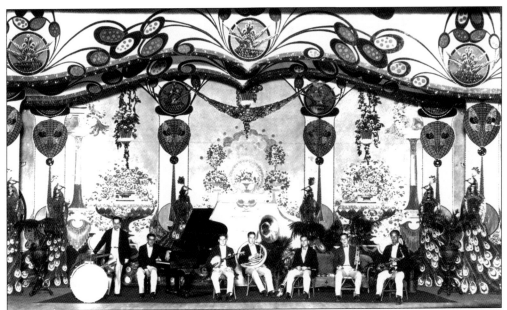

THE WOLVERINE ORCHESTRA. In 1924, Gennett Records issued a series of recordings by the Wolverines. It was the first time anyone had heard cornetist Bix Beiderbecke. Seeking to bring the best new talent to his orchestra in Detroit, Jean Goldkette was immediately interested in Beiderbecke. Seen here at the Palace Theatre in Indianapolis are, from left to right, Vic Berton, Dick Voynow, Bob Gillette, Min Leibrook, Jimmy Hartwell, Bix Beiderbecke, and George Johnson. (Courtesy of the Duncan Schiedt collection.)

LEON BISMARCK "BIX" BEIDERBECKE (1903–1931). Leon Bismarck "Bix" Beiderbecke had already made a name for himself as the "hot" cornetist of the Wolverines when Jean Goldkette invited him to audition in Detroit in 1924. Bix saw the Jean Goldkette Orchestra and its Victor recording contract as a leap to the big time. While union difficulties caused some delays, he eventually joined the band as a full-time member in 1926. (Courtesy of the Duncan Schiedt collection.)

JEAN GOLDKETTE AND THE GRAYSTONE. The Graystone Ballroom (left) was built in 1922. Owned by a bank, the initial management was unable to make it profitable. In hopes of turning things around, Jean Goldkette (below) was asked to assume the management duties. By that time, Goldkette had built an impressive reputation as musical director for the Detroit Athletic Club and by providing musical contingencies for venues throughout the city. Attempting to build the Graystone's image beyond what he called a "dance hall," Goldkette decided to remodel it after the grandeur of the Detroit Athletic Club. With an eye on making his orchestra the centerpiece, he determined to assemble the greatest band in the country. By 1924, he was off to a good start. The band's personnel already included Bill Rank, Don Murray, and Tommy and Jimmy Dorsey. (Left, courtesy of the Duncan Schiedt collection; below, courtesy of Josh Duffee, Alan Krivor, and the Jean Goldkette Foundation.)

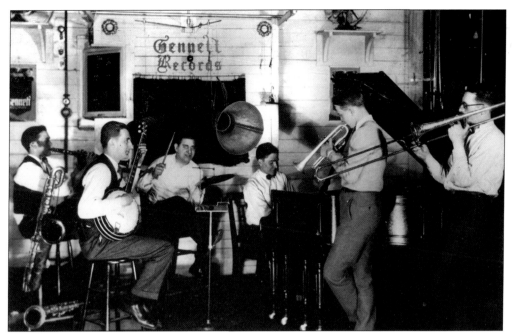

BIX AND HIS RHYTHM JUGGLERS. On January 26, 1925, Bix Beiderbecke and members of the Goldkette band recorded as Bix and His Rhythm Jugglers for Gennett Records. This photograph was taken during the session. From left to right are Don Murray (clarinet), Howard "Howdy" Quicksell (banjo), Tom Gargano (drums), Paul Mertz (piano), Bix Beiderbecke (cornet), and Tommy Dorsey (trombone). (Courtesy of the Duncan Schiedt collection.)

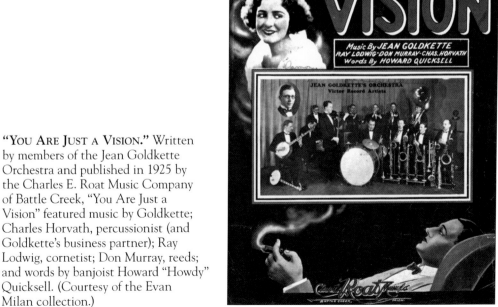

"YOU ARE JUST A VISION." Written by members of the Jean Goldkette Orchestra and published in 1925 by the Charles E. Roat Music Company of Battle Creek, "You Are Just a Vision" featured music by Goldkette; Charles Horvath, percussionist (and Goldkette's business partner); Ray Lodwig, cornetist; Don Murray, reeds; and words by banjoist Howard "Howdy" Quicksell. (Courtesy of the Evan Milan collection.)

SLAPPIN' THE BASS. An important addition to Jean Goldkette's band was Theodore "Steve" Brown (1890–1965), an early pioneer of "slapping" the bass. Most people had never heard someone slap the bass when the band recorded "Dinah" in 1926. According to Goldkette, when Brown began recording his solo, the director stopped the band, thinking it was a gag. It became the first recorded slap bass solo on a record. (Courtesy of the Charlie Rasch collection.)

JIMMY DORSEY (1904–1957). When Jean Goldkette set out to build the greatest band in America, his brilliant clarinet and alto-sax player Jimmy Dorsey convinced him to add his brother Tommy and a fellow Pennsylvania pal named Bill Challis. In time, all three would become giants in the history of big-band jazz. Jimmy Dorsey's "Oodles of Noodles," (right) was one of his most successful novelty sax solo compositions.

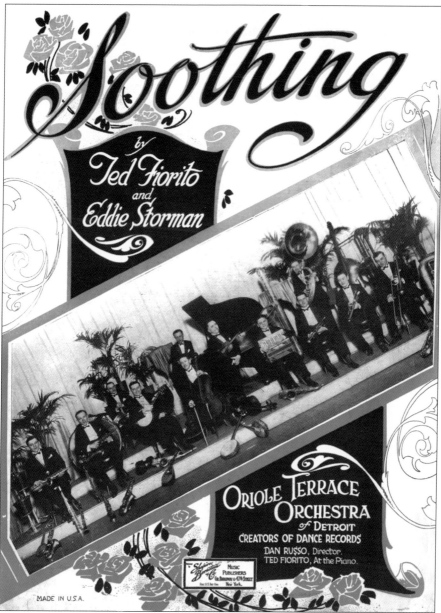

ORIOLE TERRACE ORCHESTRA. The 1922 song "Soothing," by Ted Fiorito and Eddie Storman, features a cover photograph of the Oriole Terrace Orchestra, which operated as the house band at Detroit's Oriole Terrace Ballroom during the early to mid-1920s. The band was originally based in Chicago with leadership shared by Ted Fiorito and Dan Russo. During its long-term Detroit engagement, the orchestra made many records for Brunswick and Victor, sometimes featuring songs written by coleaders Russo and Fiorito (most notably, "Toot, Toot, Tootsie, Goo'bye"). In time, Fiorito and Michigan-born Russo parted company, and the band returned to Chicago under Russo. Over the years, Fiorito continued to lead bands and garnered considerable fame as a songwriter. Detroit's Oriole Terrace was one of the city's most popular ballrooms; located along West Grand Boulevard, the building still stands. In later years, it became Jean Goldkette's Fantasia Ballroom and the "Latin Quarter."

CLAYTON NASET (1895–1966). Reed virtuoso and composer Clayton "Babe" Naset was a standout in Detroit's Oriole Terrace Orchestra. Originally from Stoughton, Wisconsin, Naset was working as a musician in Chicago when he wrote the million selling "Dreamy Melody," and "Susie," which was recorded by Bix Beiderbecke and the Wolverines. His affiliation with Ted Fiorito and Dan Russo led to an extended run at Detroit's Oriole Terrace Ballroom and a successful recording relationship with Brunswick Records. Naset played tenor, soprano sax, and the rothphone, a rare double-reed instrument on which he solos in the band's recording of "Rose of the Rio Grande." The photograph of the Wolverines (below) was a cherished item from the band's reed man, George Johnson. The inscription reads: "To Babe, any saxophonists' idol—from a friend. Geo L. Johnson." (Courtesy of the Robert Essock collection.)

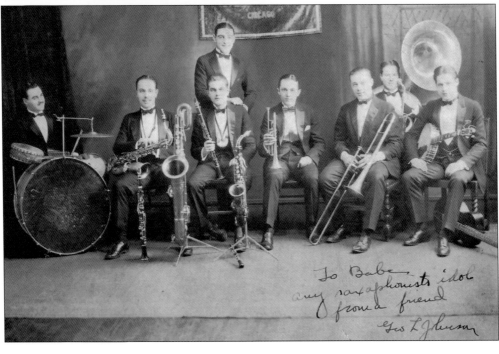

GERALD MARKS (1900–1997).
One of Detroit's most prolific songwriters, Gerald Marks grew up in Saginaw, later paying it tribute in the song "Wanigas" (Saginaw backwards). Marks spent many years in Detroit as a bandleader and songwriter, producing several hits, including "All of Me," (with Seymour Simons). Among his best known songs are "That's What I Want for Christmas," and "Is It True What They Say About Dixie?" (Courtesy of the Rudy Simons collection).

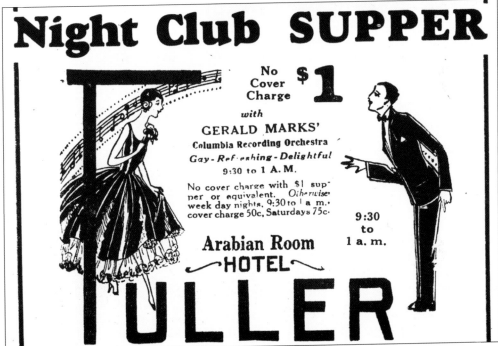

GERALD MARKS AT THE TULLER. This advertisement from a mid-1920s Detroit theater program invites patrons to dance to Gerald Marks's Columbia Recording Orchestra. Marks held court in the Hotel Tuller's Arabian Room for many years, and modern readers may marvel a bit at the promise of an evening's entertainment and a $1 supper.

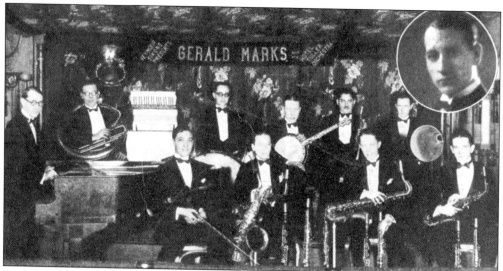

GERALD MARKS AND HIS COLUMBIA RECORDING ORCHESTRA. Gerald Marks's house band at Detroit's Hotel Tuller (pictured above) made several commercially successful sides for the Columbia label. Billed as Gerald Marks's Hotel Tuller Orchestra, the recordings included peppy dance numbers, ballads, and waltzes. Reminiscing about the sessions, the band's trombonist, William Fletcher, recalled that one of the sessions was held during a winter cold snap, and the studio was so frigid he had to place his trombone near the radiator to keep it in tune. The bands recording of "I'd Walk a Million Miles (to Be a Little Bit Nearer to You)," features a vocal by Fletcher, and the song was written by Marks and fellow Detroit songwriter Al Lewis. (Below, courtesy of the Charlie Rasch collection.)

THE MITCHELL RECORD. In the 1920s, no major record label was headquartered in Detroit. One of the few labels associated with the city was the Mitchell. Existing between 1924 and 1926, they were actually produced out-of-state and outfitted at the factory with the local Mitchell label. The rarest and most sought after Mitchell is Jelly Roll Morton's recording of "Mr. Jelly Lord" and "Steady Roll." (Courtesy of the Montgomery archive).

THE MITCHELL PHONOGRAPH. The Mitchell Phonograph and Consolidated Talking Machine Company was a family operation, originally housed in a lone storefront at the corner of Gratiot Avenue and Mitchell Street. Felix Sadowski was the company president, and family members helped run the business. The company sold phonographs that were actually manufactured by the Wisconsin Chair Company of Port Washington, Wisconsin. The "local" Mitchell brand labels were affixed at the factory.

THE CORNER OF GRATIOT AND MITCHELL. Founded in 1921 with $5,000 in capital, the Mitchell Phonograph Corporation was originally located at 2957 Gratiot Avenue in this two-story brick building located at the corner of Gratiot and Mitchell Street. The Sadowski family undoubtedly appropriated the Mitchell Street name for use on their records and phonographs. At the time of this writing, the building still stands. (Photograph by Greg Hathaway.)

AT 3000 GRATIOT AVENUE. According to Detroit city directory records, the Mitchell Phonograph Corporation relocated in 1925, reestablishing the shop and headquarters in a larger facility located directly across the street at 3000 Gratiot Avenue. In later years, this building became part of a warehouse for the Society of St. Vincent DePaul and burned to the ground in 1995. (Photograph by Greg Hathaway.)

Six

SONG OF DETROIT

By the late 1920s, Detroit had ascended to some notable peaks. The automobile industry was thriving; new car models offered greater speed, streamlined designs, and a new array of colors. Ford's Model A was proving a sensation, and people were singing its praises in the song "Henry's Made a Lady Out of Lizzie." It was a significant recovery for the Ford Motor Company, which saw sales stumble in the mid-1920s, due to a reluctance to keep up with emerging trends and the embarrassing scramble for "damage control" in the wake of Henry Ford's anti-Semitic articles in the *Dearborn Independent*.

In music, Detroit seemed to be closing the decade at the top. Remick was still a giant of the publishing world, and Jean Goldkette had introduced the nation to two of the most popular bands of the jazz age—his own Jean Goldkette Orchestra and McKinney's Cotton Pickers. Meanwhile, Goldkette's Orange Blossom Band was gaining notoriety at Toronto's famed Casa Loma and in time would adopt its name and soon take a major role in the emerging big band "swing" movement.

Detroit in the late 1920s was alive with theaters, ballrooms, dance halls, and, of course, speakeasies. By 1929, trade in illicit alcoholic beverages coming in from Canada was thriving. In fact, it had become the second-most profitable industry in the city and accounted for more than 75 percent of the alcoholic beverages coming into the United States.

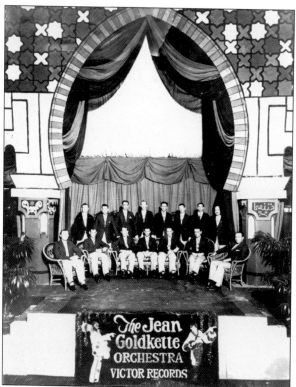

JEAN GOLDKETTE ORCHESTRA, VICTOR RECORDS. The Jean Goldkette Orchestra poses for a Victor Records publicity still in the spring of 1927. From left to right are (first row) Don Murray, Frank Trumbauer, Ray Lodwig, Bill Rank, Bix Beiderbecke, Chauncey Morehouse, and Eddy Sheasby; (second row) unidentified, Fred "Fuzzy" Farrar, Howard "Howdy" Quicksell, Steve Brown, Irving "Itzy" Riskin, Newell "Spiegle" Willcox, unidentified, and Stanley "Doc" Ryker. (Courtesy of the Duncan Schiedt collection.)

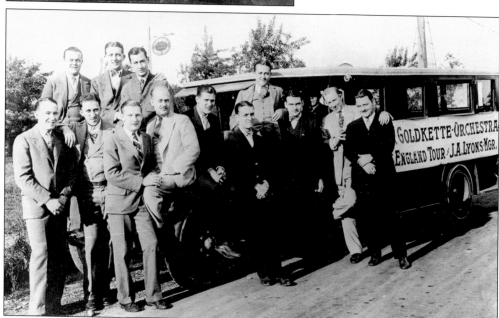

THE 1927 NEW ENGLAND TOUR. The Goldkette band poses in front of the tour bus during its 1927 New England tour. From left to right are (first row) Ray Lodwig, Irving "Itzy" Riskin, Newell "Spiegle" Willcox, Stanley "Doc" Ryker, Bill Rank, Chauncey Morehouse, Bix Beiderbecke, Bill Challis, Steve Brown and Fred "Fuzzy" Farrar; (second row) Don Murray, Howard "Howdy" Quicksell, and Frank Trumbauer. (Courtesy of the Duncan Schiedt collection.)

BIX, DON, AND HOWDY. Several photographs and home movie clips survive from the Goldkette band's 1926 New England tour. This photograph, taken in an unknown location, finds three members in a moment of nonmusical recreation. Howard "Howdy" Quicksell is perched on a wooden or stuffed horse, while Don Murray uses the tail as a mustache. Bix Beiderbecke sits in front with his arm around the back leg. (Courtesy of the Duncan Schiedt collection.)

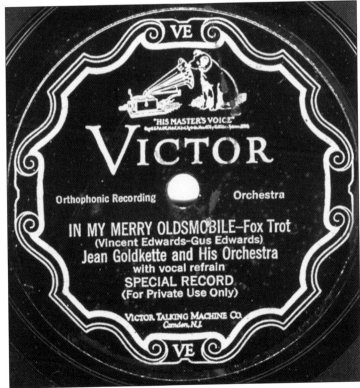

THE UNNUMBERED VICTOR. In 1927, General Motors commissioned the Jean Goldkette Orchestra to produce a promotional record for its upcoming convention. Featuring two different versions (a fox trot and a waltz) of the 1905 song "In My Merry Oldsmobile," it was given to participants at the convention. Recorded as a special record, it was not issued a Victor catalog number, and is among the rarest of Goldkette recordings. (Courtesy of the Hester collection.)

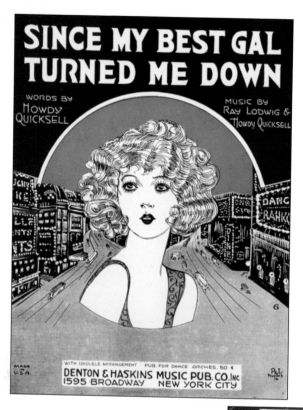

"SINCE MY BEST GAL TURNED ME DOWN." One of the most familiar songs written by members of the Jean Goldkette Orchestra, "Since My Best Gal Turned Me Down" was penned by Ray Lodwig and Howdy Quicksell. While the Goldkette band never recorded it, the song was immortalized as a jazz classic when Bix Beiderbecke recorded it on the Okeh label in 1927, performing as Bix Beiderbecke and His Gang. (Courtesy of the Montgomery archive.)

"TRUMBOLOGY," 1927. Frank Trumbauer's C-melody, novelty saxophone solo, "Trumbology," issued here as an alto-sax solo with piano accompaniment, was published by Robbins. Trumbauer (Tram) recorded it for Okeh in 1927 in an arrangement by Paul Mertz with band members selected from Goldkette's orchestra, including Beiderbecke, Jimmy Dorsey, Bill Rank, Paul Mertz, Eddie Lang, and Chauncey Morehouse. (Courtesy of the Montgomery archive.)

"RAY AND HIS LITTLE CHEVROLET."
In the 1920s, Detroit's automobile
industry remained a popular song
topic, and although "Ray and his Little
Chevrolet" (1924) had no corporate
affiliation, it could easily have
served as a promotional song. It even
incorporated the company's trademark
on its cover. It is a song about Ray
who never got a date until he bought
a Chevrolet. Now, Ray "gets more girls
than Ruth gets homers!"

"SLEEPY TIME GAL." Not many
restaurants can claim a hit song as their
own, but Juilleret's Family Restaurant of
Harbor Springs can! It was at Juilleret's
one night in 1925 when four Detroit
song writers—Joseph Alden, Raymond
Egan, Ange Lorenzo, and Richard
Whiting—put their heads together
and wrote the popular standard,
"Sleepy Time Gal." Needless to say, it
was also the first place the tune was
ever performed.

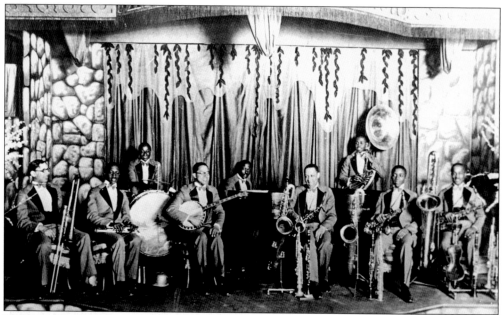

McKinney's in Toledo. According to historian John Chilton, Jean Goldkette first heard McKinney's Synco Jazz Band in 1925 at the Green Mill in Toledo, Ohio. Booking them into the Arcadia Ballroom, he requested they change their name to the Cotton Pickers. Seen here in Toledo in 1926 are, from left to right, Claude Jones, John Nesbitt, Cuba Austin, Dave Wilborn, Todd Rhodes, Milton Senior, June Cole, George "Fat Head" Thomas, and Wesley Stewart. (Courtesy of the Charlie Rasch collection.)

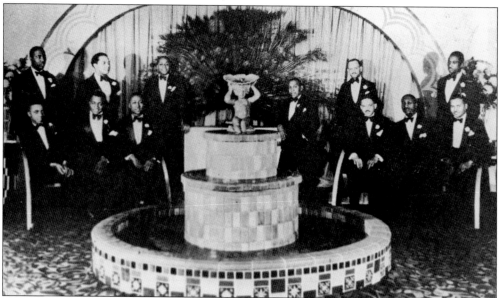

McKinney's Cotton Pickers at the Graystone Ballroom. Despite the high payroll of his own recording orchestra, Jean Goldkette soon found that the public favorite at the Graystone Ballroom was actually McKinney's Cotton Pickers. Contracted with Goldkette in 1926, the band began recording for Victor in 1928. In the photograph above, the band is seated around the well-known cherub fountain of the Graystone Ballroom. (Courtesy of the Charlie Rasch collection.)

CLAUDE JONES AND COLEMAN HAWKINS. McKinney's Cotton Pickers' trombonist, Claude Jones (1901–1961), is pictured here with Coleman Hawkins (1904–1969). Originally from Oklahoma, Jones is known chiefly as a trombonist but is also featured on recordings as a vocalist and could play several instruments. Jones played and recorded with Don Redman, Duke Ellington, Fletcher Henderson, Coleman Hawkins, and Cab Calloway. (Courtesy of the Duncan Schiedt collection.)

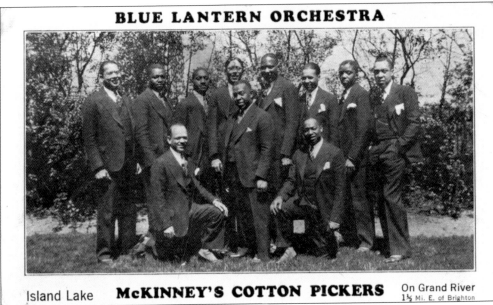

BLUE LANTERN ORCHESTRA

Island Lake **McKINNEY'S COTTON PICKERS** On Grand River 1½ Mi. E. of Brighton

McKINNEY'S COTTON PICKERS. "Dear friend—McKinney's Cotton Pickers Opening Dance at the Blue Lantern, Island Lake, is on Wednesday, May 22nd," reads the reverse of this 1929 advertising postcard. McKinney's had become a major staple of Jean Goldkette's Detroit-based National Amusement Corporation and one of the most popular recording bands in the country. The Blue Lantern was near New Hudson, about 40 miles from Detroit. (Courtesy of the Montgomery archive.)

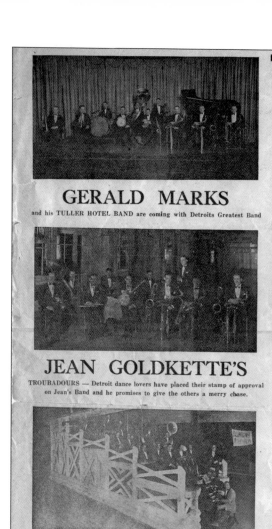

GERALD MARKS

and his TULLER HOTEL BAND are coming with Detroits Greatest Band

JEAN GOLDKETTE'S

TROUBADOURS — Detroit dance lovers have placed their stamp of approval
on Jean's Band and he promises to give the others a merry chase.

KING JOE

and his famous Sunset Serenaders a band of tremendous volume
and individual Stars

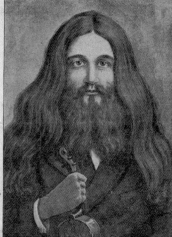

PAUL DEACON

LET THEM

Thes
and if you were to
Specta

PAUL DEACON

Band of unprecede
every civilized nati
dia Ballroom with
Musicians. Their B
highly skilled in e
greatest interpreter

SH
h
Con
the
and
De

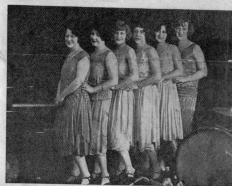

15 FAMOUS
BROADWAY
FOLLIES STARS

CALIFOR
GREATEST F
A Bevy of Bea

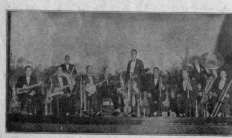

EDGARS CREOLE BAND

FO
BROTH
FAMO
BAN
and
Saxaph
Sexte

THURSDAY F

ARCADIA'S 12 ORCHESTRA EXTRAVAGANZA! The fold-out section of the 12 Orchestras Arcadia flier provides a rare glimpse at some of the musical acts that participated in the event. While the selection of bands provided personnel that were black, white, male, and female, the audience would have undoubtedly been white as, even in Detroit, there was a segregated policy for ballroom attendance, with certain nights specifically set aside for African Americans. It should be noted

THEMSELVES

rs of Art

u'll never enjoy a more
of Bands.

e Internationally Fam-
avid Bluebeard Band, a
aving toured practically
are coming to the Arca-
Orchestra of 18 Master
e best trained and most
lay they stand as the
azz.

EDWIN
RITTER

o holds an
iable record
naving play-
n practically
ery Cafe in
Michigan

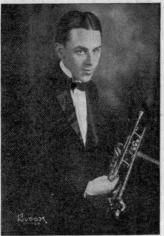

JERRY ARMS

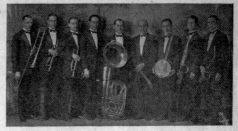

SEYMOUR SIMON

and his Capitol Theatre Band. — The Super-Master of Syncopation is coming
to Arcadia with his orchestra

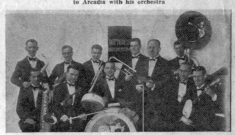

EDWIN RITTER'S

Famous Cafe Band playing in practically all of Michigan and Ohio's prominent
Cafes. They boast of a band that is different and all they say is
"just wait and see"

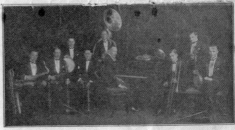

RUSSIAN CAVALIERS

Imperial Band conducted by Irvin S. Kaskey who has gained great distinction
as being an unusual artist of syncopation

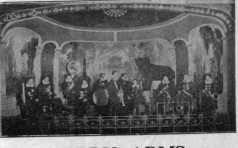

JERRY ARMS

BRIDES
D ON EARTH
by can they play

**FAMOUS
BROADWAY
FOLLIES STARS** **15**

OOK'S
riginal
troiters

of all the
l Jazz Bands
world is com-
with his fam-
IXIE SERE-
NADERS

10TH **Dancing 'till 3**

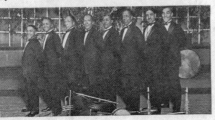

that the band advertised as Edgar's Creole Band is most likely Charlie Elgar's Creole Band, an
African American jazz band that recorded for Brunswick and Vocalion during the period. The
flier also bills the Jean Goldkette Orchestra as Goldkette's Troubadours, suggesting it may have
been a smaller contingency of the full orchestra. (Courtesy of the Montgomery archive.)

12—ORCHESTRAS—12
HOUSE OF DAVID
BLUEBEARD BAND ONLY BAND OF ITS KIND IN THE WORLD
California Jazz Brides

Playing in conjunction with

"America's Greatest"

GERALD MARKS
JEAN GOLDKETTE
KING JOE
EDGAR CREOLES
SEYMOUR SIMON
EDWIN RITTERS
RUSSIAN CAVALIERS
JERRY ARMS
SHOOKS DETROITERS
FOX BROTHERS

VIOLET McAFEE
Female **"ASH"** of California
Conductor of the Famous
CALIFORNIA JAZZ BRIDES
Greatest All-American Female Jazz Team in the World

ARCADIA
BALLROOM
3527 WOODWARD

THURSDAY, FEBRUARY 10TH
DANCING FROM 7 TO 3 IN THE MORNING
REGULAR HOLIDAY PRICES WILL PREVAIL *(No Extra Charge for Wardrobe and Dancing)*

12 ORCHESTRAS! February 10, 1927, must have been a big night for jazz and dance music in Detroit. In a rare flier advertising the "Famous Dance Band Championship of America," the Arcadia Ballroom promotes an evening featuring 12 bands, with "Dancing from 7 until 3 in the morning." In the advertisement, the assortment seems to run from the commonplace to the bizarre, with performances by the House of David Bluebeard Band (the only band of its kind in the world), the California Jazz Brides (an all-female band), Ben Shook's Detroiters, and the orchestras of Gerald Marks, Jean Goldkette, and Seymour Simons. (Courtesy of the Montgomery archive.)

HANK BIAGINI'S ORCHESTRA. Detroit's Henry (Hank) Biagini band is seen here at the Adolphus Hotel in Dallas, Texas (above). From left to right are Henry Biagini (leader), George Troup (trombone), Fred Ross (alto), John Vido (violin), Bob Zurke (piano), Noni Bernardi (alto), Cliff Johnson (tenor), Wayne Smith (trombone), Jimmy Nolan (alto), Joe Lucas (trumpet), Red Phillips (trumpet), John Fansher (bass), and Mel Fudge (drums). Below is Biagini's Orchestra using Jean Goldkette's (JG) music stands. From left to right are (first row) Cliff Johnson (tenor), Fred Ross (alto), Noni Bernardi (alto), Jimmy Nolan (alto), and John Vido (violin); (second row) Henry Biagini (standing), Wayne Smith (trombone), George Troup (trombone), Red Phillips (trumpet), and Joe Lucas (trumpet); (third row) John Fansher (bass), Mel Fudge (drums), and Bob Zurke (piano). (Courtesy of the Duncan Schiedt collection.)

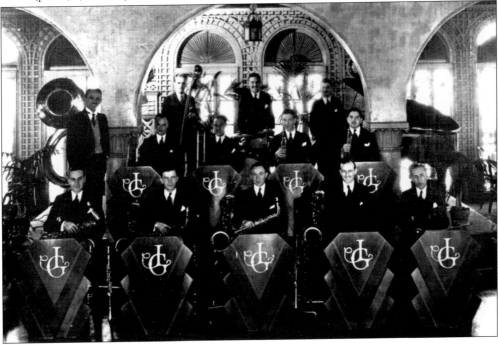

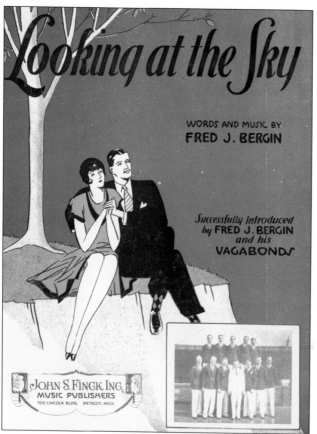

FRED BERGIN AND HIS VAGABONDS. Detroit pianist Fred Bergin, longtime pianist with many Goldkette organizations, led a dance band known as the Vagabonds in the early 1930s. The band is pictured on the cover of Bergin's song, "Looking at the Sky," published in 1930. In the photograph below, the Vagabonds pose for a photograph in September 1930 in the Graystone Gardens. From left to right are (first row) Slim Branch (trombone), Bull (Bill?) Snodgrass (guitar), Chris Fletcher (guitar/violin), Skeeter Palmer (accordion), Steve Brown (bass), Les White (trombone), Fred Bergin (piano), and Herb Fischer (sax); (second row) Hilly Edelstein (sax), unidentified (drums), Wally Urbanski (clarinet), Babe Routh (sax), and Frank Zullo (trumpet). (Left, courtesy of the Montgomery Archive; below, courtesy of the Duncan Schiedt collection.)

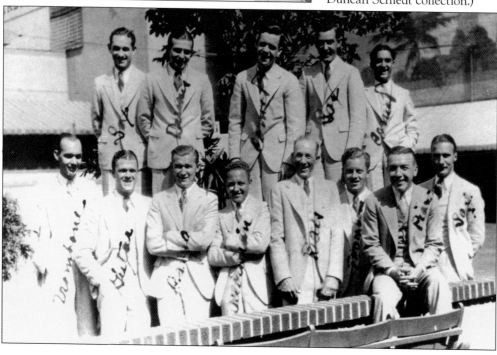

GOLDKETTE'S BLUE LANTERN. Among the many satellite dance venues operated, managed, or booked through Jean Goldkette's National Amusement Corporation, the Blue Lantern was one of the most well known. Situated on the edge of Island Lake, between New Hudson and Brighton, the Blue Lantern was only about 10 miles north of the college towns of Ann Arbor and Ypsilanti. This rare brochure dates from the mid-1920s. (Courtesy of the Hester collection.)

Jean Goldkette's
BLUE LANTERN
BALLROOM
ISLAND LAKE

On Grand River, one and one-half miles east of Brighton. Six miles west of New Hudson.

NOTICE!
This pamphlet contains coupons which will be accepted as FIFTY CENTS in the purchase of admission tickets.

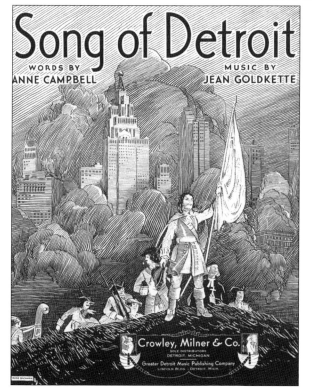

SONG OF DETROIT, 1930. Jean Goldkette continued to be a fixture in Detroit for many years. While he seldom composed, he did provide music for "Song of Detroit," a 1930 composition with lyrics by Detroit poet Anne Campbell. Originally commissioned by the Crowley, Milner and Company department store to mark its 22nd anniversary, the song was later reissued (1951) to mark the city's 250th birthday. (Courtesy of the Montgomery archive.)

"LIKE A BIRD CHIRPIN' IN THE RAIN." Written by Sidney Holden, "Like a Bird Chirpin' in the Rain" was published in 1930 by the John S. Finck Company of Detroit. Despite the song's obscurity, it is notable for the cover, featuring an artist's rendering of the Oriole Terrace interior. It also states the number was "successfully" introduced by the Oriole Orchestra. The song credits Harry P. Guy as the arranger. (Courtesy of the Montgomery archive.)

LEROY SMITH ORCHESTRA. As a classically trained violinist, Leroy Smith sought to bring an orchestrated polish to his recordings, while maintaining a popular jazz appeal. The band's 1928 recording of "St. Louis Blues" was issued to capitalize on the song's inclusion in the Broadway show, *Blackbirds of 1928.* Although originally composed in 1914, W. C. Handy's classic song resurfaces frequently and has remained a standard for nearly a century. (Courtesy of the Montgomery archive.)

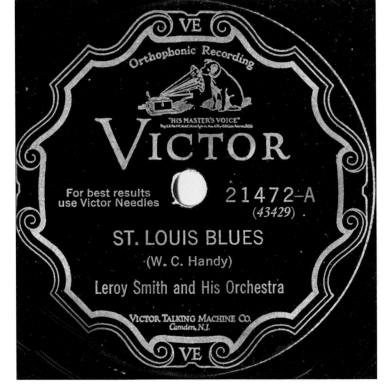

"ALL OF ME." Detroit songwriters Seymour Simons and Gerald Marks had written songs before, but the 1931 hit "All of Me" would be their most famous collaboration. In fact, it would become one of the most popular and familiar songs of all time, recorded more than 2,000 times. The sheet music (right) features a cover photograph of bandleader Paul Whiteman, and it was his orchestra's recording that initially made the song a hit, featuring a vocal by a then up-and-coming singer named Mildred Bailey. By 1928, during the first wave of financial troubles that ultimately toppled Goldkette's Detroit empire, Whiteman had signed most of the personnel that made the Jean Goldkette Orchestra famous. Below, a promotional photograph of Simons shows the popular Detroit songwriter surrounded by the covers of his many hit songs. (Courtesy of the Rudy Simons collection.)

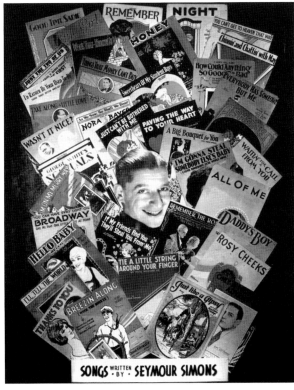

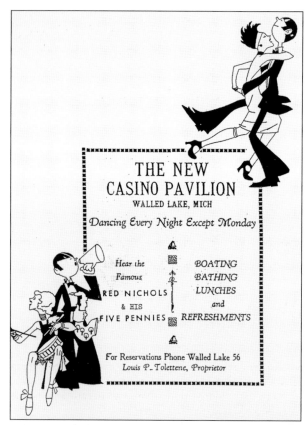

THE NEW
CASINO PAVILION
WALLED LAKE, MICH

Dancing Every Night Except Monday

Hear the BOATING
Famous BATHING
RED NICHOLS LUNCHES
& HIS *and*
FIVE PENNIES REFRESHMENTS

For Reservations Phone Walled Lake 56
Louis P. Tolettene, Proprietor

JAZZ IN THE HINTERLANDS. John Held Jr.'s iconic 1920s characters flank the advertisement for Walled Lake's New Casino Pavilion. The popular nightspot was known for featuring top names among music acts. The advertisement on the left heralds the appearance of Red Nichols and his Five Pennies. The late Rip Collins, a local banjoist, fondly recalled a night in the late 1920s playing for a high school dance across the street, when the world-famous Red Nichols strolled in and asked him to fill in for his ailing banjo player. The late-1920s postcard below features an interior shot from Walled Lake's dance hall days with the stage set for an appearance by the Broadway Collegians. (Courtesy of the Hester collection.)

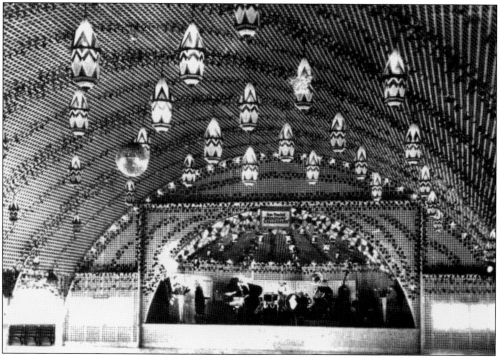

Seven

BROTHER, CAN YOU SPARE A DIME?

Unlike most decades whose fads, fashions, and stylistic earmarkings briefly extend into the next, the 1920s came to an abrupt halt in October 1929. For Detroit, and other industrial centers across America, the affects of the crash were particularly hard—banks were failing, jobs had vanished, and entertainment had suddenly become a luxury few could afford.

The music of the Great Depression reflects the mood of the times. Songs with any glimmer of optimism seem to convey a glaring sarcasm and an underlying hopelessness. The recordings of the period seem heavy, dour; many have a dirgelike quality. Even the love songs of the early depression seem colored by the bleak times, and for radio listeners (and the few who could afford to buy phonograph records), the standard fare became songs like "We Can Live on Love," "When Your Lover Has Gone," "Gloomy Sunday," and "Brother, Can You Spare a Dime?"

In the years surrounding the Wall Street crash, most of the record companies and music publishers that had come to prominence during the 1920s either merged, became absorbed, or simply went out of business. In Detroit, Jean Goldkette's National Amusement Corporation was coming apart. His all-star band had moved on, and McKinney's Cotton Pickers had changed its representative management. Most of the Detroit songwriters, bandleaders, and musicians had departed, leaving for New York or Hollywood. Those that remained found other means of employment. Many, like Goldkette and Harry P. Guy, would eventually die penniless and all but forgotten.

**"HULLABALOO,"
1930.** Despite
lethargic record sales
precipitated by the
Great Depression,
recordings by
McKinney's Cotton
Pickers continued
to sell reasonably
well. Their 1930
Victor recording of
"Hullabaloo" features
banjoist Dave Wilborn
on the vocal. Notice
that the label reflects
the Radio Corporation
of America's (RCA)
purchase of Victor in
1929. (Courtesy of the
Montgomery archive.)

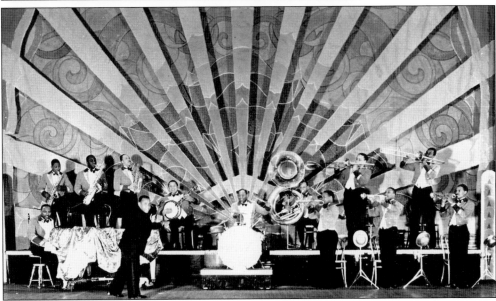

McKinney's Onstage. Performing in New York City in front of a sunburst backdrop in 1931, McKinney's Cotton Pickers are caught in action. From left to right are Jimmy Dudley (sax), Prince Robinson (sax), Edward Inge (sax), Dave Wilborn (banjo), Cuba Austin (drums), Ralph Escudero (sousaphone), George "Buddy" Lee (trumpet), Quentin Jackson (trombone), Clarence Ross (trumpet), Ed Cufee (trombone), Langston Curl (trumpet), with Todd Rhodes (piano) and Don Redman (director) in front. (Courtesy of the Hackley Collection.)

"Brother, Can You Spare a Dime?" In 1932, Detroit songwriter Jay Gorney (1894–1990) composed the national anthem of the Great Depression. In the classic song, written for the Broadway show *Americana*, Gorney and lyricist E. Y. "Yip" Harburg captured the national sentiment following the collapse of what many characterized as the American dream. Its haunting melody and unmitigated disillusionment seem as pertinent today as when it was first written.

NATIONAL AMUSEMENT CORPORATION. The size and reach of Jean Goldkette's National Amusement Corporation can be discerned by this 1929 advertisement. With 20 bands (3 of them major recording units) and affiliation with radio stations nationwide, it seems hard to believe his empire would soon be toppled. Unfortunately, the devastation of the Depression took an incredible toll on the music industry, and Goldkette soon found himself with dim prospects. (Courtesy of the Montgomery archive.)

CASA LOMA ORCHESTRA. Formed in 1927, Detroit's Orange Blossom Band was originally under management of Jean Goldkette's National Amusement Corporation. While playing an extended engagement at Toronto's famous Casa Loma (then a popular nightclub and luxury hotel), the band changed its name, and in 1929, it embarked on a successful recording career. The band is pictured on the cover of "Lazybones" from 1933. Bandleader Glen Gray stands at center.

SPONSORSHIP. Radio created a level of star power that advertisers were quick to pick up on, and musicians soon found there was money to be made in product endorsements. Here the brass section of the Casa Loma Orchestra appears in a 1935 advertisement for Bach instruments. From left to right are Billy Rauch, Sonny Dunham, Grady Watts, "Pee Wee" Hunt, Bobby Jones, and Fritz Hummel. (Courtesy of the Montgomery archive.)

KELLOGG'S PEP ON THE AIR. Battle Creek's cereal giant Kellogg's was also quick to pick up on the value of radio program sponsorship. With top stars like Ruth Etting and Red Nichols, its NBC program "College Prom—Pep on the Air" promoted the healthful benefits of Pep cereal by featuring famous athletes and focusing on a different college campus each week. (Courtesy of the Hester collection.)

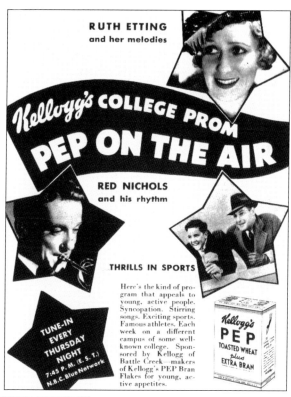

"MAY WE COME IN?" Coming into listeners' living rooms each week over the airwaves via Detroit radio station WWJ, Detroit bandleader Seymour Simons knocks on the door (in this case, a cigar box creates the perfect sound effect) and asks his trademark question, "May we come in?" Familiar catch phrases and theme songs were becoming recognized as valuable commercial identity trademarks in the early days of radio. (Courtesy of the Rudy Simons collection.)

LAFAYETTE THEATRE

ETHEL WATERS

"Rhapsody in Black"

Beginning SUNDAY, MAY 1st

Matinees Wednesday and Saturday

ETHEL WATERS, *RHAPSODY IN BLACK*. In the 1930s, escape from the strife of the Depression became less affordable yet all the more desirable. Here Ethel Waters (1896–1977) graces the cover of a 1932 program from Detroit's Lafayette Theatre for a touring production of *Rhapsody in Black*. Waters broke many barriers—her popularity crossed racial lines, and she was one of the first openly gay entertainers in the industry.

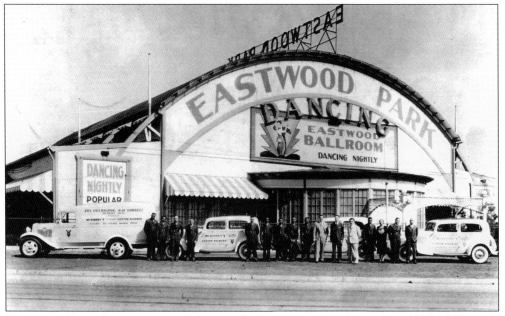

EASTWOOD PARK. In a promotional photograph from its coast to coast tour in 1934, McKinney's Cotton Pickers stand in front of Detroit's Eastwood Park Ballroom. No longer under the management of Jean Goldkette and Don Redman, the band is represented by Detroit's Del Delbridge and Ray Gorrell, while William McKinney maintained the directorship of the band. (Courtesy of the Hackley Collection.)

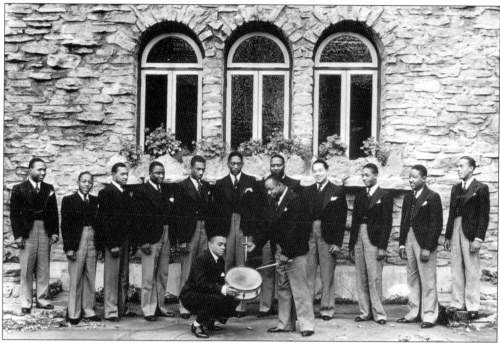

DETROIT, 1934. McKinney's, listed here as the Original Cotton Pickers, pose in a publicity still near the Graystone Ballroom in 1934. From left to right are (first row) Billy Bowen and Cuba Austin; (second row) George "Buddy" Lee, Roy Eldridge, Charles Moore, Prince Robinson, Ed Cufee, Billy McClure, Todd Rhodes, Dave Wilborn, Jacob Wiley, Jimmy Dudley, and Joe Eldridge. Below, an undated photograph from the 1930s shows the Cotton Pickers standing in front of the stone wall that once surrounded Detroit's Whitney mansion. The photograph was taken directly across the street from the Graystone Ballroom and Gardens. While the wall no longer exists, the mansion is now a historic landmark and operates as a restaurant. (Courtesy of the Hackley Collection.)

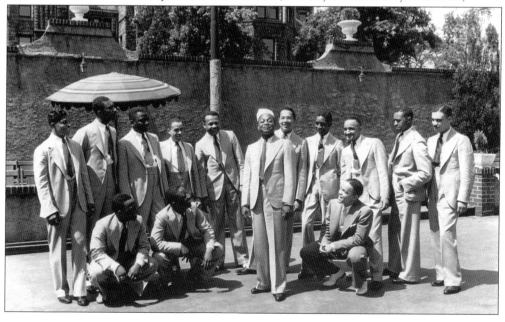

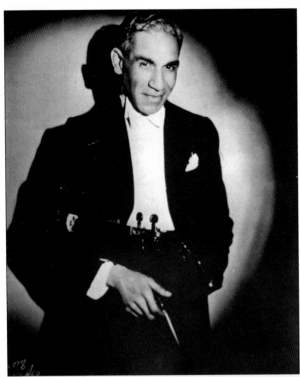

LEROY SMITH AND THE WPA.
A distinguished, visibly older
Leroy Smith returned to Detroit
permanently in 1938. He had
success leading bands, recording,
and acting as musical director for
shows in New York, but with the
responsibility of caring for his
widowed mother, Smith needed to
find work in a Depression-ravaged
Detroit. Realizing his inestimable
value, the government named
him state supervisor of the WPA
musicians aid program. (Courtesy of
the Hackley Collection.)

DETROIT MUSIC AND SPORTS. Detroit Tigers George "Birdie" Tebbetts and Eldon Auker share a
laugh with bandleaders Seymour Simons (second from left) and Eddy Duchin (far right) in Detroit
in 1937. Simons's son, Rudy, has fond memories of Duchin, a close friend of his father's. "He even
took me to a Tiger game," noted Simons, recalling when Duchin stood in for Rudy's father who was
unable to attend due to band scheduling conflicts. (Courtesy of the Rudy Simons collection.)

TOMMY DORSEY (1905–1956). In 1960, Jean Goldkette reminisced about recording in a makeshift studio at the Detroit Athletic Club. It was 1925 and young Tommy Dorsey's first recording session. Afterwards an inebriated Dorsey stood in the intersection of Woodward Avenue and Canfield Street, stopped traffic and shouted, "I am a Victor recording artist!" By the time he graced the cover of "Once in a While" in 1937, he had come a long way.

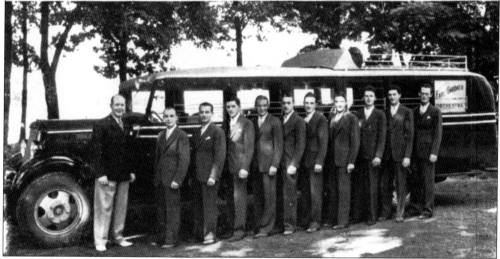

"THE BAND WITH A MILLION FRIENDS." The Earl Gardner Orchestra poses with its tour bus, promoting an appearance at Kalamazoo's Gull Lake Hotel. The card notes they bring "$10,000 worth of stage and traveling equipment, including public address and amplifying system." Given the obvious financial challenges of motoring across the country with a large touring band, it is little wonder that the big band era was running out of time.

STALE BEER, ASHTRAYS, DANCING, AND DRUMS. Souvenirs of a thousand lost weekends from Detroit's jazz age and swing era populate the page. Matchbooks from the Hotel Tuller, Bagley Cocktail Bar, Dakota Inn, and Hotel Fort Shelby flank a coaster inviting everyone to the Michigan Room of the Hotel Statler. Swizzle sticks conjure memories of one too many and offer up names of nightspots, now mostly distant memories: Club Alamo, Fenmore Cocktail Lounge, Falcon Theatre Lounge, Club 58 Lothrop, and Baker's Keyboard Lounge. A wooden mallet from the Flame Show Bar brings to mind the harrowing notion of a room full of drunken patrons trying to beat time along with the band. The ticket book and tickets from the Arcadia Ballroom (below) sit beside a pocket mirror advertising an upcoming appearance of the Broadway Collegians at Detroit's Mirror Ballroom.

VOGUE RECORDS. Detroit-based Vogue Records made a colorful mark in the final days of the big band era. Founded in 1946 by Tom Saffady, Vogue records are among the most recognizable and widely collected discs ever pressed. Under the artistic direction of Detroit songwriter and bandleader Seymour Simons (pictured at right with the founder), Vogue Records featured recordings by some of the biggest names in entertainment at the time. The discs (pictured below) often featured colorful illustrations depicting the subject matter of the recorded selections or images of the featured artists. With limited material and distribution capabilities, the company quickly fell on hard times, and bankruptcy was declared in 1947. Despite the short lifespan, Vogue Records are much sought after by collectors. (Right, courtesy of the Rudy Simons collection; below, courtesy of the Montgomery archive.)

MARGARET WHITING, BORN 1924.
A Detroit latecomer to the age of big bands is vocalist Margaret Whiting. Born in Detroit in 1924, Whiting is the daughter of songwriter Richard Whiting and the niece of recording artist Margaret Young. Whiting showed amazing vocal ability even as a child. When longtime family friend and songwriter Johnny Mercer founded Capital Records in 1942, he immediately signed the 18-year-old Margaret to a recording contract.

DIXIE FIVE. During the 1940s and 1950s, small group traditional jazz made a comeback of sorts in the form of a revival. One of Detroit's best ensembles of the revival movement was the Dixie Five, featuring some Detroit jazz-age veterans. From left to right are Eph Kelly, Frank Gillis, Andy Bartha, Doc Cenardo, and Clyde Smith. (Courtesy of the Montgomery archive.)

Eight

SONGS WE USED TO SING

It is not possible to assign a date to the end of the swing era and the age of the big bands. It happened over time and for a number of reasons. The war was diverting the national attention and things changing at home and abroad sometimes went unnoticed. In America, the new generation of jazz musicians began moving away from the structural rhythmic and harmonic confines of the older style. Economics and the availability of personnel dictated that small group jazz would become more prevalent. At the same time, other contingents began emphasizing a vocal dominant style of music with strong roots in the blues that incorporated a more driving, boogie-style rhythm.

By the end of the 1940s, the newer form of jazz had moved away from the mainstream, and rock and roll moved in. Jazz had been relegated to the periphery, and its days of market domination had effectively ended. Ironically, rock and roll recordings continued to mirror the same format and structure of the popular recordings of the 1920s. While more vocally dominant, most follow a closely related pattern, setting aside sections for solo improvisation over the allotted chord structures.

Over the past years, there have been many individuals throughout Michigan who have actively made a contribution to keeping ragtime and traditional jazz music alive through performances, recordings, compiling archives, writing histories, and even continuing to compose music of the genres.

This last chapter is a look at some of Michigan's notable standouts in the area of jazz and ragtime preservation. While space and available photographs do not permit some inclusions, the author would like to mention a few people not presented in the pictorial who deserve to be recognized. These include Morris Lawrence, William Albright, Kenneth and Barbara Cox, Lars Bjorn, Jim Gallert, John Teachout, and Warren Ross. There are more that deserve mention, and hopefully there will someday be a book covering the work of all these individuals in the future.

WILLIAM BOLCOM. One of America's greatest living composers, William Bolcom has made a trademark of drawing on and incorporating ragtime and traditional jazz elements into his vast library of solo pieces, chamber works, choral compositions, and expansive symphonic works. Bolcom has composed more than 25 piano rags and, as composer in residence at the University of Michigan, has enlightened and influenced many students and budding composers.

JOAN MORRIS. Mezzo-soprano Joan Morris has dedicated a significant part of her life's work to performing and recording historically authentic recreations of songs from America's golden age and the ragtime era. While rarely heard in their original form, Morris has provided important historic insight to the genres. In addition to being a world-renowned artist, Morris has been an adjunct associate professor of theater at the University of Michigan since 1981.

NAN BOSTICK. As a historian, educator, and pianist, Nan Bostick is focused on preserving the music and people of the ragtime era. She is a grandniece of Charles N. Daniels and his chief biographer. Dividing her time between a variety of musical pursuits, Bostick has provided concerts and lectures throughout the country. With Dr. Nora Hulse, she is coauthor of "Ragtime's Women Composers: An Annotated Lexicon" published in the *Ragtime Ephemeralist* in 2002.

ARTHUR LABREW. One cannot conduct research on Detroit's musical heritage without encountering the name Arthur LaBrew. No one has made greater efforts on the subject or knows more about it. As a historian and musicologist, he is a lifelong truth seeker, myth buster, and one of music history's greatest advocates. Author of more than 30 volumes, LaBrew is a virtuoso pianist, cherished teacher, and one of Detroit's unforgettable personalities.

MIKE MONTGOMERY. Known to almost everyone who has even a casual interest in ragtime and jazz history, Mike Montgomery is a pianist, collector, historian, lecturer, archivist, and one of the friendliest ambassadors the musical genres have ever known. His name graces countless books on ragtime and early jazz, for which he has meticulously compiled, cataloged, and provided organized rollographies, song lists, and discographies.

DUNCAN SCHIEDT. His work transcends many genres; photographer, archivist, historian, and author. In each, his love of the music shines through, enhancing its beauty and mystique. A celebrated photographer, his work has been featured in countless publications, museums, and documentaries. His own publications include *Ain't Misbehavin': The Story of Fats Waller, The Jazz State of Indiana,* and *Jazz in Black and White: The Photographs of Duncan Schiedt.* (Photograph by Jim Hair.)

DUNCAN SCHIEDT JUNE, 2008 Photograph © by Jim Hair

CATHY STEPHENS AND THE PLEASANT MOMENTS VINTAGE DANCERS. Internationally recognized social dance instructor and historian Cathy Stephens has introduced 19th- and 20th-century social dancing to thousands of dance enthusiasts throughout North America. She is the founder and director of the Pleasant Moments Vintage Dancers (PMVD) performance company. Stephens also serves as artistic director and instructor for the Grand Traditions Vintage Dance Academy (GTVDA). Founded by Arlynn Hacker, the GTVDA is an Ann Arbor organization that sponsors dance classes and period balls. Below, members of the PMVD pose for a publicity still. Pictured are, from left to right, (first row) Jackie Aldridge, Dave Keosaian, Cathy Stephens, Robin Warner, and Peggy Amrine; (second row) JoAnn Keosaian, Bill McEwen, Sheri King, Bruce Amrine, Helen Welford, Bill Stephens, and Arlynn Hacker.

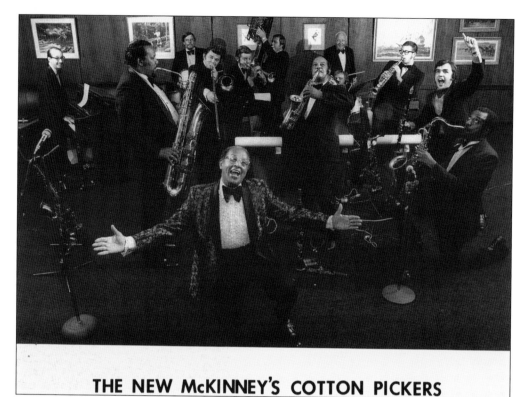

THE NEW McKINNEY'S COTTON PICKERS

DAVE WILBORN (1904–1982). As one of the last original members of McKinney's Cotton Pickers, Dave Wilborn was a jazz-age veteran and one of the most exuberant and dedicated jazz preservation advocates Detroit has ever known. In the 1970s, he organized the New McKinney's Cotton Pickers, presenting the band's music to a whole new audience. He also led the fight, trying in vain, to save the Graystone Ballroom from demolition.

RUDY SIMONS. While working tirelessly as one of Michigan's most honored humanitarian and civil rights activists, Rudy Simons has also dedicated time and attention to supporting the preservation of Michigan's musical heritage. As the son of songwriter Seymour Simons, Rudy has been an invaluable source of information and images chronicling Detroit's unique contribution to Tin Pan Alley. As a pianist, lyricist, and member of ASCAP, Rudy has continued the family tradition.

CHARLIE RASCH. One of Detroit's longtime stride piano masters, Charlie Rasch has enjoyed a performing and recording career that stretches more than 50 years. While his strong and powerful style was forged in the tradition of James P. Johnson and Jelly Roll Morton, his attack and interpretation are all his own. Always attentive to historical context, Rasch has been instrumental in preserving a brand of piano playing seldom heard today.

RAGTIME CHARLIE AND SISTER KATE. First brought to national attention in *They All Played Ragtime*, pianist Charlie Rasch and banjoist Kate Ross were Michigan favorites for decades, providing authentic recreations of ragtime and traditional jazz music. Joining forces in the early 1960s, under the management of the late Warren Ross, the duo made a number of fine recordings and successfully presented several historic genres to a new generation of listeners.

ROYAL GARDEN TRIO. After encountering the recordings of Eddie Lang and Django Rienhardt, virtuoso guitarist and onetime rocker Brian Delaney changed gears and organized the Royal Garden Trio (RGT). Specializing in a unique form of hot, bluesy, small-group jazz, the trio features the incredible talents of Tom Bogardus (reeds and tenor guitar) and Mike Karoub (cello). With several critically acclaimed recordings, they are quickly becoming a popular international favorite. (Photograph by Richard A. Jones.)

THE RIVER RAISIN RAGTIME REVUE (R4). A mouthful of a name, and an earful of music. Based in Tecumseh, under executive director William Pemberton and artistic director William Hayes, this 12 piece, nonprofit orchestra "educates and entertains via presentation of America's original musical style—ragtime." Over the years, they have performed with many internationally acclaimed artists including Bobby McFerrin, Smokey Robinson, Harry Connick Jr., Dionne Warwick, and Mannheim Steamroller.

120

KERRY PRICE. A powerful pianist with superb vocal talents, Kerry Price has packaged her many talents into a popular one-woman show, which she has presented across the country. In her many years as an educator teaching voice, choral music, and directing choirs, she has always provided students a steady diet of ragtime, jazz, and the blues and even taught a course on the history of jazz at Detroit Country Day School.

MR. B. As a child, Mark Braun played classical and pop piano, until he heard a record by Jimmy Yancey—it changed his life. Seeking out boogie masters, applying a rigorous practice regimen, and developing a distinctly personal style, he eventually emerged as "Mr. B," a boogie giant and popular international favorite. Mr. B keeps the tradition alive at home with his annual Ann Arbor Blues and Boogie Piano Celebration.

JOSH DUFFEE AND HIS ORCHESTRA.
The legacy of the Jean Goldkette
Orchestra lives on in the present day
through the efforts of bandleader,
percussionist, and historian Josh
Duffee. Based in Bix Beiderbecke's
hometown of Davenport, Iowa, Josh
Duffee (pictured at left) and his
orchestra have gained worldwide
notoriety by painstakingly recreating
the original band charts and
recordings of the Jean Goldkette band.
They are a regular favorite at the Bix
Festival held every July in Davenport.
Below, in a recreation of a mid-1920s
Goldkette band photograph roster
are the current members of the Josh
Duffee Orchestra. From left to right
are (bottom row) Josh Hahn, Crystal
Duffee, and Kristian Svennevig;
(second row) Earle Johnson, Julie
Craighead, Travis Lopez, and Chuck
Comella; (third row) Jamey Cummins,
Alan Knapper, Matt Sivertsen, and
Bruce Bogen; (fourth row) Scott
Angelici, Josh Duffee, and David
Abdo. (Courtesy of Josh Duffee).

JAMES DAPOGNY. While he has left an indelible impression as a musician, educator, historian, and musicologist, it is Jim Dapogny's warmth and willingness to encourage and mentor others that has left the greatest impression on those who know him. Still his work has proven indispensable to many, including his transcriptions of Jelly Roll Morton piano solos and the reconstruction of James P. Johnson's long-lost opera, *De Organizer.*

PORK. Providing a rare opportunity to sample first-generation, big-band jazz of the 1920s, Phil Ogilvie's Rhythm Kings (PORK) was organized in 2000 by Jim Dapogny and Chris Smith. The 10-piece band features some of the finest and most authentic renditions of jazz masterpieces (both known and unknown) that one can hear today and has been a Sunday afternoon favorite at Ann Arbor's Firefly Club for many years running.

BOB SEELEY. Considered one of the greatest living boogie pianists, Bob Seeley's notoriety and reputation is well known throughout the world. His love of boogie piano goes back to his childhood, listening to records by Meade Lux Lewis. Later the two would become close friends. While he calls Michigan home, Seeley has traveled the world amazing audiences from Carnegie Hall to Russia. (Photograph by Charlie Rasch.)

ROMIE MINOR, THE HACKLEY COLLECTION. This book was made possible through assistance of the E. Azalia Hackley Collection of Negro Music, Dance and Drama, Detroit Public Library. Currently under the direction of archivist Romie Minor, the collection was founded in 1943. Minor's efforts in the process are much appreciated. A fellow Arcadia Publishing author, Minor partnered with Laurie Ann Tamborino for *Detroit's Thanksgiving Day Parade*, a highly recommended book.

STAN AND STEVE HESTER. The Hesters share a lifelong love of 1920s jazz, and together they have compiled a nearly complete discography of "Red" Nichols's nearly 45-year recording career. Coauthors of *The Red Nichols Story*, a 1997 bio-discography, they have always possessed an unselfish willingness to share information, recordings, and assistance to fellow historians, biographers, and researchers. Seen at right is Stanley Hester; below is Steve Hester.

BOB MILNE. Originally a virtuoso French horn player trained at the Eastman School of Music, Bob Milne found solace and joy in playing classic rags on the piano. In time, he became a master interpreter of ragtime, early jazz, and boogie. A celebrated lecturer, performer, and recording artist, Milne has been a featured guest throughout the world and is still a favorite back home in Michigan.

STRIDE RIGHT! Powerhouse pianists Charlie Rasch (left) and Bob Seeley clown for the camera in the late 1960s. Gaining notoriety throughout the past 40 years, Rasch and Seeley are popular stylists of historic forms of piano jazz and blues. Rasch has made many recordings and been a local fixture for many years. Seeley, a master stride player in his own right, is an internationally renowned champion of boogie woogie.

BIBLIOGRAPHY

Bjorn, Lars, and Jim Gallert. *Before Motown: A History of Jazz in Detroit, 1920–1960*. Ann Arbor, MI: University of Michigan Press, 2001.

Blesh, Rudi, and Harriet Janis. *They All Played Ragtime*. New York: Alfred A. Knopf, 1950.

Bostick, Nan, and Dr. Nora Hulse. "Ragtime's Women Composers: An Annotated Lexicon." *Ragtime Ephemeralist* 3 (2002).

Bostick, Nan, and Arthur R. LaBrew. "Harry P. Guy, and the 'Ragtime Era' of Detroit, Michigan." *Ragtime Ephemeralist* 2 (1999).

Bostick, Nan. "Meet Uncle Charlie." *Rag Times* 32, no. 3 (1998).

Charters, Samuel B., and Leonard Kunstadt. *Jazz: A History of the New York Scene*. Garden City, NY: Doubleday, 1962.

LaBrew, Arthur R. *The Detroit History Nobody Knew*. 2 vols. Detroit, MI: self-published, 2001.

Rust, Brian L. *American Record Label Book*. New York: Da Capo Press, 1984.

———. *Jazz Records, 1897–1942*. London, England: Storyville Publications, 1983.

Sudhalter, Richard M., and Phillip R. Evans. *Bix, Man and Legend*. New Rochelle, NY: Arlington House, 1974.

ACROSS AMERICA, PEOPLE ARE DISCOVERING SOMETHING WONDERFUL. THEIR HERITAGE.

Arcadia Publishing is the leading local history publisher in the United States. With more than 3,000 titles in print and hundreds of new titles released every year, Arcadia has extensive specialized experience chronicling the history of communities and celebrating America's hidden stories, bringing to life the people, places, and events from the past. To discover the history of other communities across the nation, please visit:

www.arcadiapublishing.com

Customized search tools allow you to find regional history books about the town where you grew up, the cities where your friends and family live, the town where your parents met, or even that retirement spot you've been dreaming about.